Create Authentic
Kemonomimi
Characters

For Cosplay, Anime & Manga

Shugao

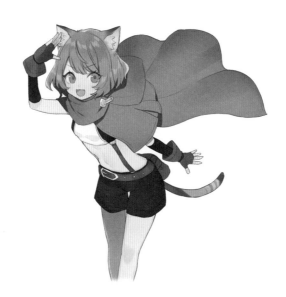

TUTTLE Publishing

Tokyo | Rutland, Vermont | Singapore

Contents

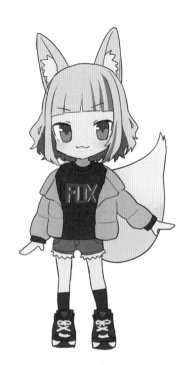

CHAPTER 1

Start with the Basics 17

CHAPTER 2

Designing Kemonomimi & Furry Characters 27

❶ Cats
Characters with Cat Ears 28

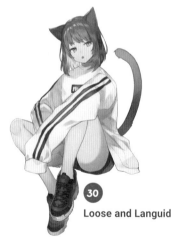

30
Loose and Languid

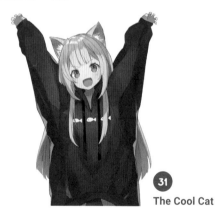

31
The Cool Cat

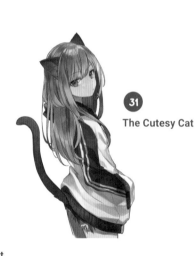

31
The Cutesy Cat

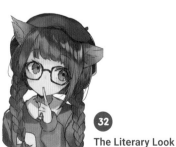

32
The Literary Look

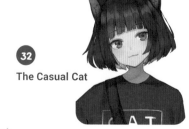

32
The Casual Cat

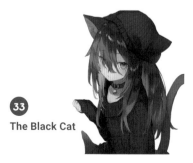

33
The Black Cat

Cat-Based Designs 34

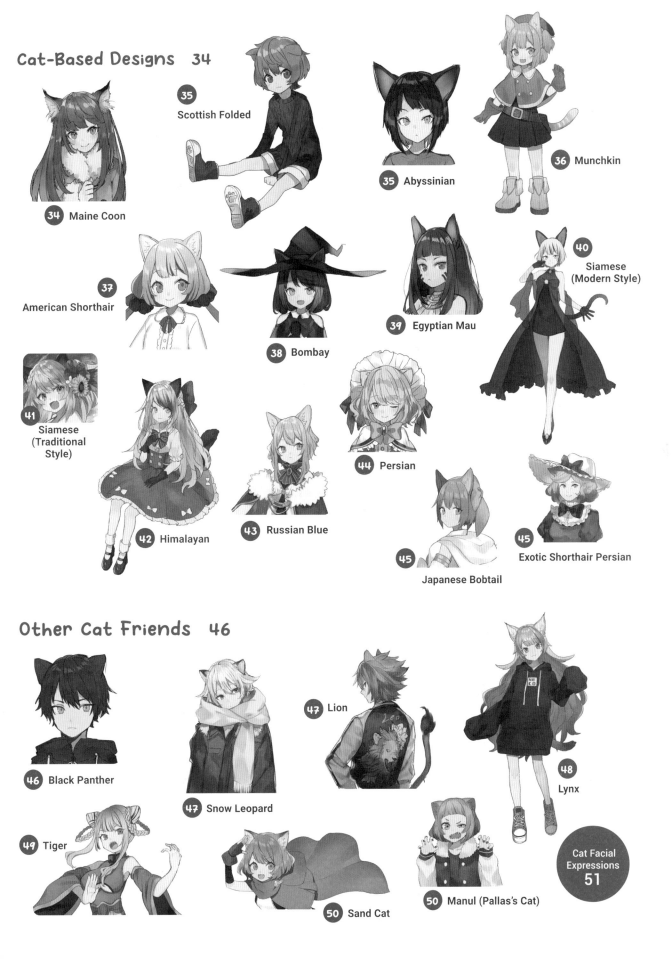

34 Maine Coon

35 Scottish Folded

35 Abyssinian

36 Munchkin

37 American Shorthair

38 Bombay

39 Egyptian Mau

40 Siamese (Modern Style)

41 Siamese (Traditional Style)

42 Himalayan

43 Russian Blue

44 Persian

45 Japanese Bobtail

45 Exotic Shorthair Persian

Other Cat Friends 46

46 Black Panther

47 Snow Leopard

47 Lion

48 Lynx

49 Tiger

50 Sand Cat

50 Manul (Pallas's Cat)

Cat Facial Expressions 51

❷ Dogs

Characters with Dog Ears 52

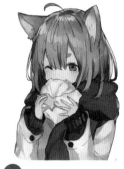

Dog Ear Designs 56

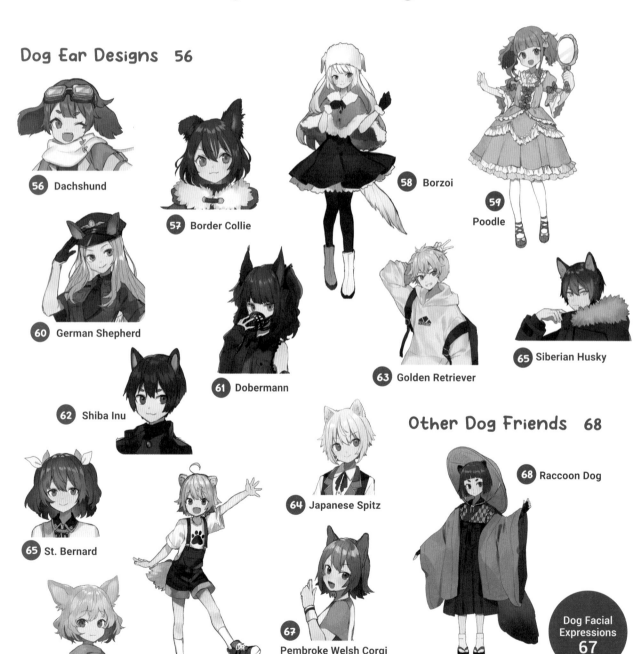

❸ Foxes

Characters with Fox Ears 70

 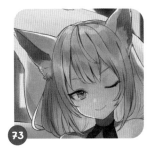 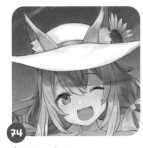

72 The "Cool Girl" **73** The Shrine Maiden **73** The Nine-tailed Temptress **74** The Vacationer

Fox Ear Designs 75

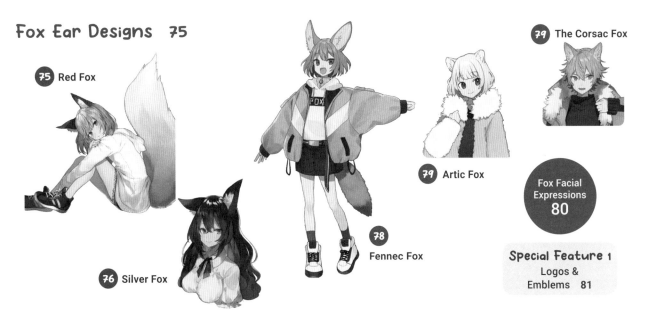

79 The Corsac Fox

75 Red Fox

79 Artic Fox

78 Fennec Fox

76 Silver Fox

Fox Facial Expressions 80

Special Feature 1
Logos & Emblems 81

❹ Wolves

Characters with Wolf Ears 82

84 The Non-threatening Wolf

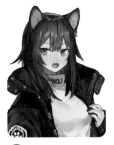

84 The Wild Wolf

Wolf Ear Designs 85

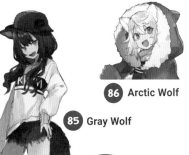 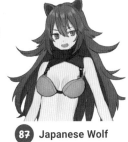

86 Arctic Wolf

85 Gray Wolf

87 Japanese Wolf

Wolf Facial Expressions 88

Special Feature 2
A Gallery of Eyes 89

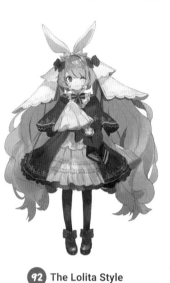

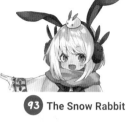
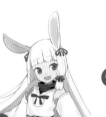
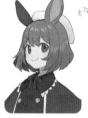
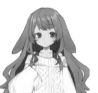
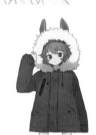
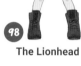

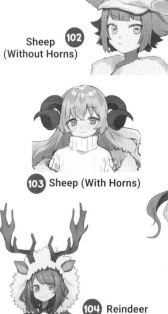
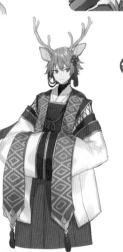
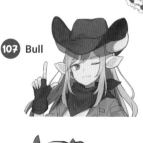

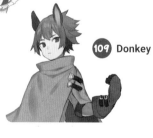
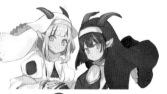

7 Birds

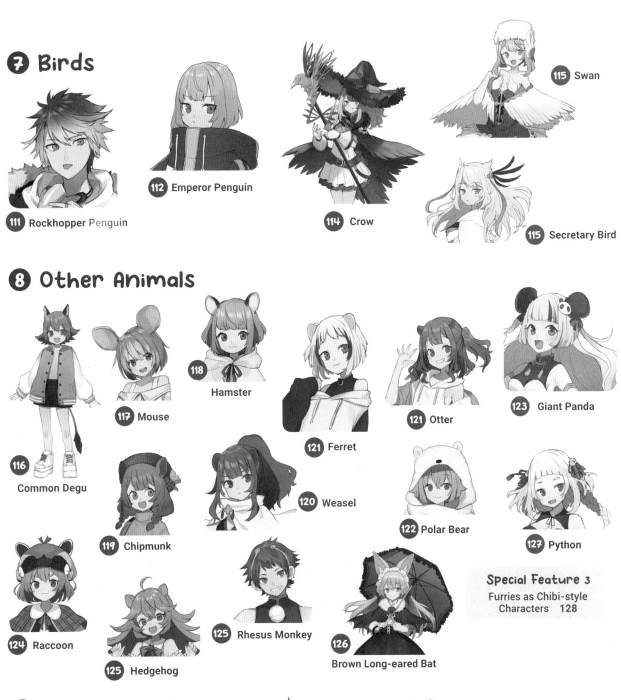

115 Swan

112 Emperor Penguin

111 Rockhopper Penguin

114 Crow

115 Secretary Bird

8 Other Animals

115 Swan

116 Common Degu

117 Mouse

118 Hamster

121 Ferret

121 Otter

123 Giant Panda

119 Chipmunk

120 Weasel

122 Polar Bear

127 Python

124 Raccoon

125 Hedgehog

125 Rhesus Monkey

126 Brown Long-eared Bat

Special Feature 3
Furries as Chibi-style
Characters **128**

9 Mythical Creatures

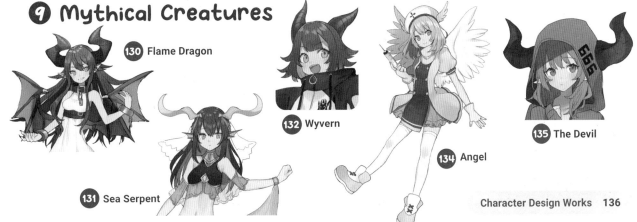

130 Flame Dragon

132 Wyvern

134 Angel

135 The Devil

131 Sea Serpent

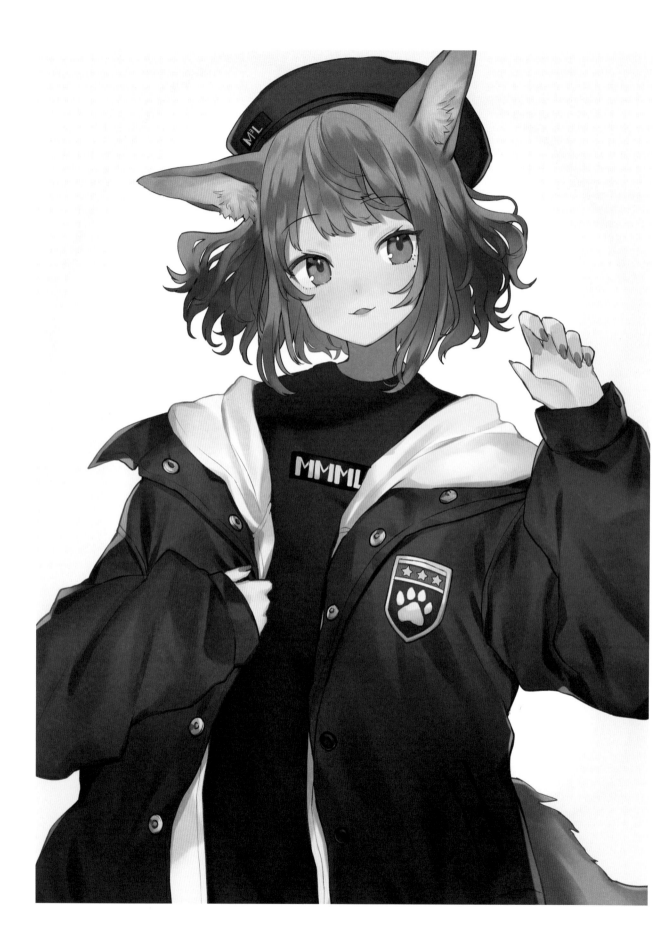

Why I Wrote This Book

Furry. Kemonomimi. Catgirl. Catboy. Sure, there are distinctions among the various residents of "furry world," but in my mind at least, the terms blurred together long ago into one vast creative category containing endless possibilities. These characters are all human-animal hybrids. Or are they animal-human fusions? Either way, they're creatures and creations the world has never seen before.

The fun and fantasy extend beyond the page and screen. Are you into cosplay? Many of my friends are, and what they come up with never ceases to amaze me. So whether you're creating characters for manga and anime or sketching one-of-a-kind cosplay designs, you're sure to find something here to inspire you.

Just remember, there are no rules. The drawings in this book are meant as examples, as springboards to the imagination. The pairings and characters are limitless, they're yours to discover, draw, design and bring to life. So enjoy the process and the possibilities and let your imagination run wild. But most of all, have fun along the way!

— Shugao

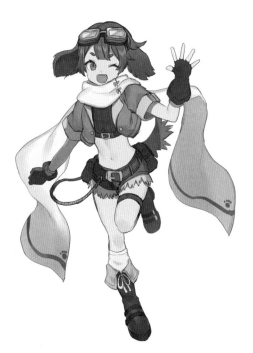

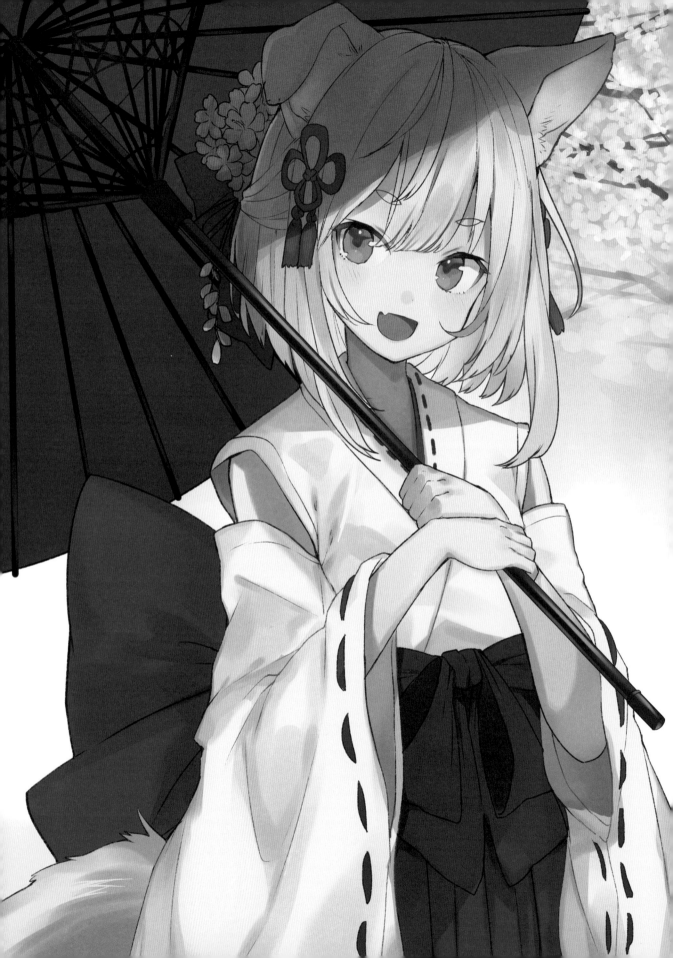

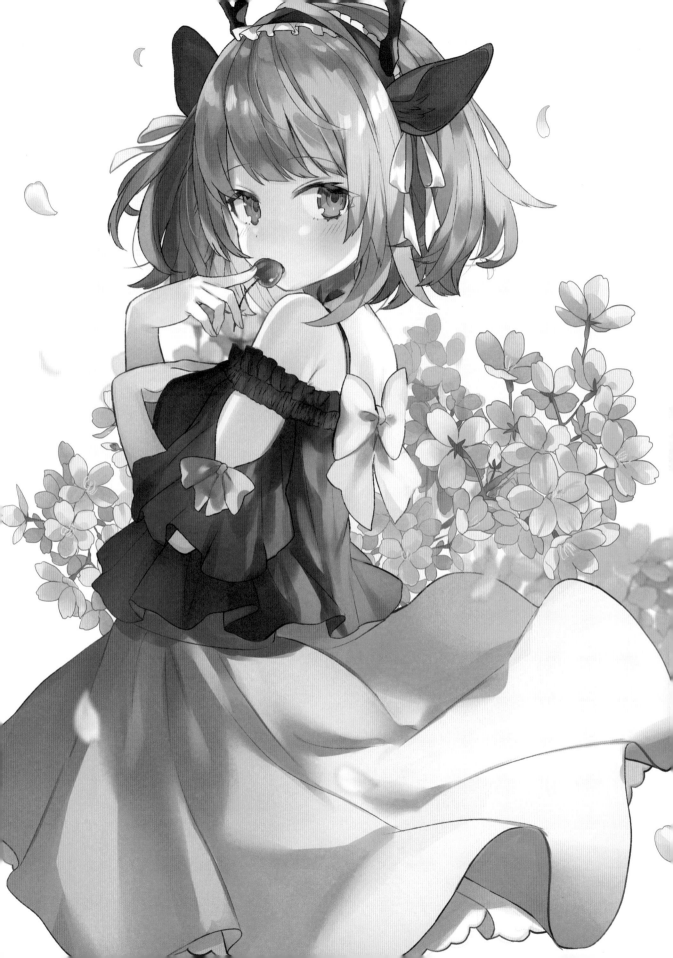

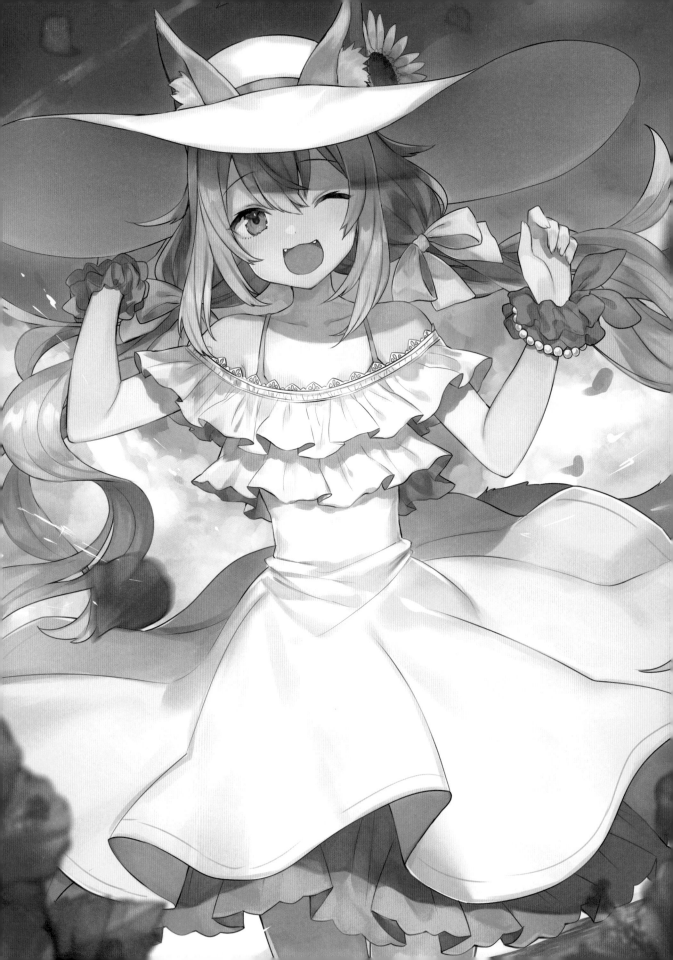

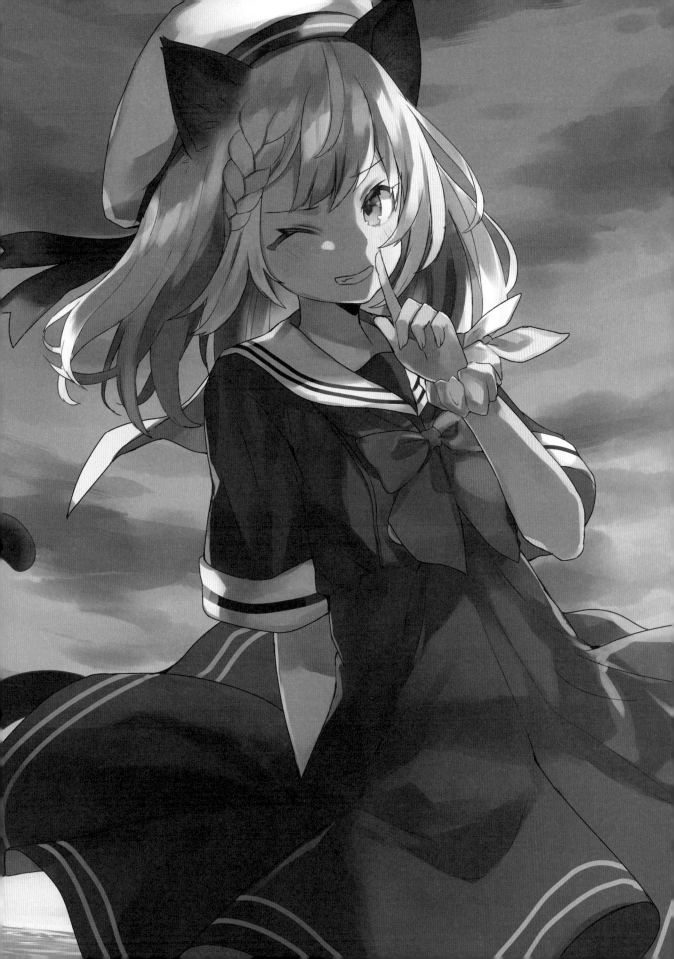

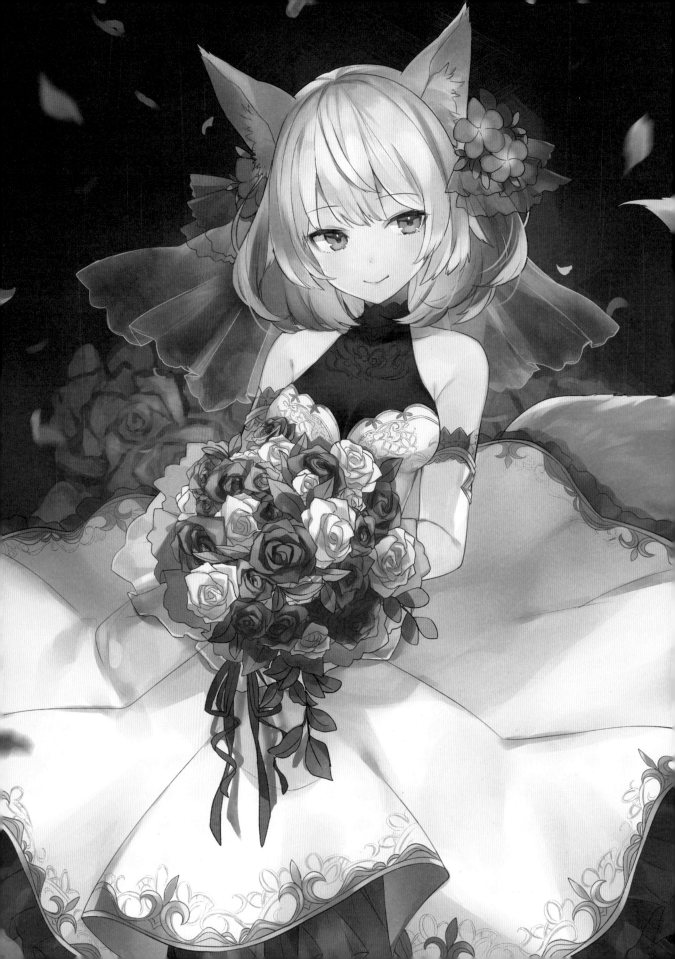

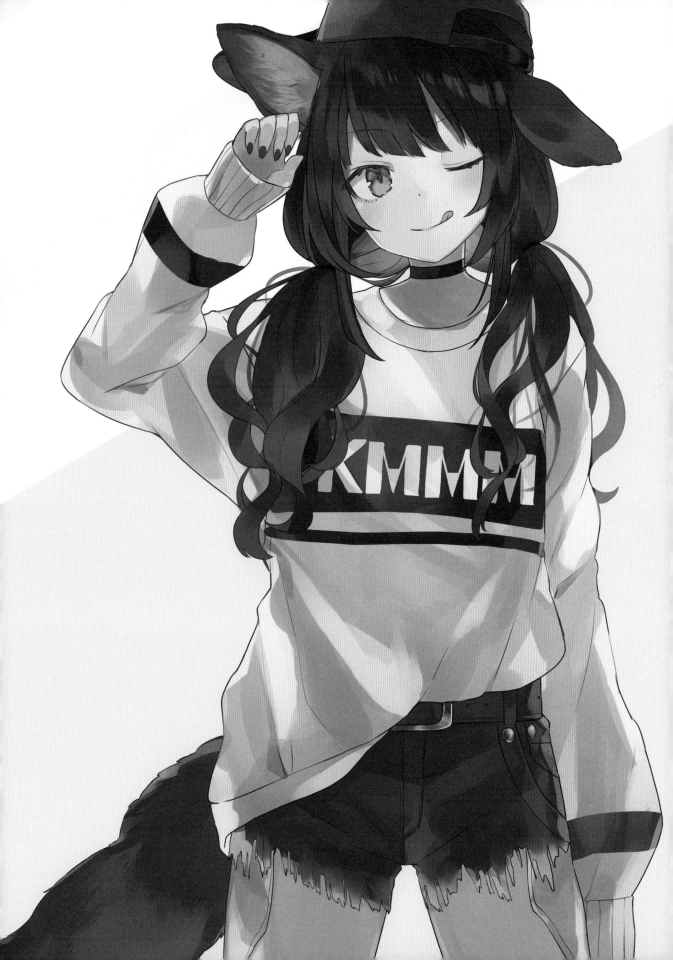

How to Use This Book

Chapter 1

Start with the Basics
A summary of kemonomimi characters
and an explanation of character designs.

Chapter 2

Designing Kemonomimi & Furry Characters
An introduction to character designs for animals
including cats, dogs and foxes.

The Basics

Here you'll find an explanation of the basic characteristics of each animal and an introduction to a range
of techniques for creating characters from pictures of each creature.

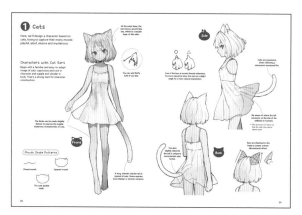

Character designs by type are also introduced.

Animal-Based Character Design

An introduction to the techniques used to create and characterize each animal-inspired design.

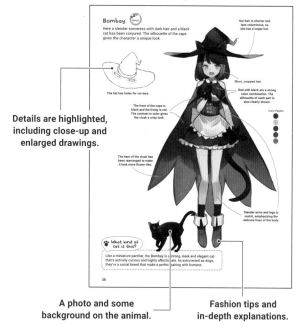

**Details are highlighted,
including close-up and
enlarged drawings.**

**A photo and some
background on the animal.**

**Fashion tips and
in-depth explanations.**

Introduction of design points and useful hints

Redesign the character by refining the
original concept

Special Feature 1

Some techniques to help with your designs.

Wolf Facial
Expressions
88

A gallery of facial
expressions for the
major animal groups

Chapter 1

Start with the Basics

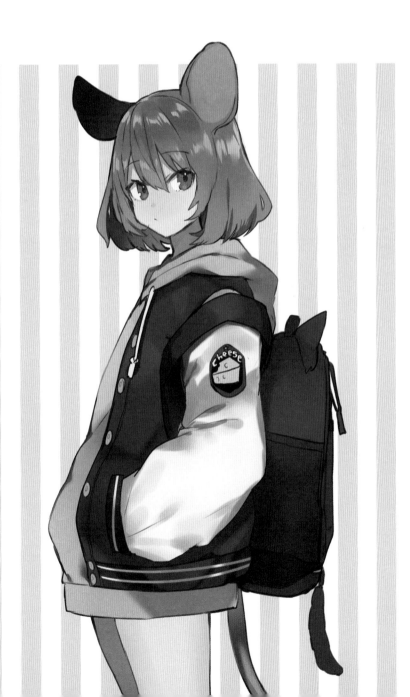

1 What Are Kemonomimi? Are They Furries?

What exactly are these hybrid creatures, with their pointed ears and a hint of bestial features? Kemonomimi (or kemomimi) are humanoid characters, sporting ears or horns and often a long swishing tail. Are they furries? It depends on your own definition, but of course they are!

All About Kemonomimi

We've all seen them: catgirls and catboys, those slinky creatures that emerged from the pages of manga and sprang into action in anime. "Kemonomimi" refers to the animal ears attached to the heads of these human-like characters.

Now the concept has evolved, and there are many variations depending on the base animal: dogs, foxes, rabbits. And now animals with horns. No matter the origin, kemonomimi characters have a unique cuteness, wildness and charm, while conveying the key qualities and characteristics of the origin animal directly to the viewer.

In addition to the tails, fangs and fur that enhance the bodies of these characters, hairstyles, clothing designs and accessories go a long way in elevating and embellishing your creations. And remember: any anthropomorphic animal is fair game, even creatures without ears such as snakes.

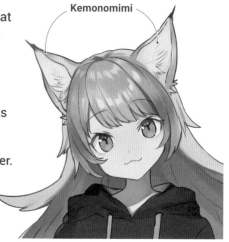

Kemonomimi

It's All About Proportion

Your character can take on any number of guises depending on where you locate it on the human-to-animal spectrum. Animal anthropomorphism takes on a wide range of expressions: do you want to accentuate the human side, or would you rather emphasize the animalistic characteristics? There's no clear line, but the respective proportions of humans and animals depend on how your character acts and is perceived. The furries and kemonomimi featured in this book are most often considered to be the closest in appearance to human form. For your own characters, it's up to you which side or blend you favor.

Closer to human ← → Closer to animal

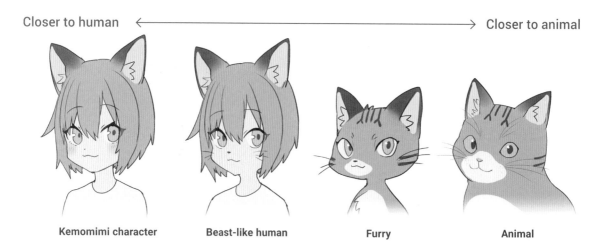

Kemomimi character Beast-like human Furry Animal

 # All About Ears

There are no set rules when it comes to adding your character's ears, but taking advantage of the position and paying attention to the placement will add to your character's distinctive look. Let's take a look at ears and some of their characteristics.

Superscript

Most animals' ears are located on the tops of their heads, a position that lends your characters a more realistic look.

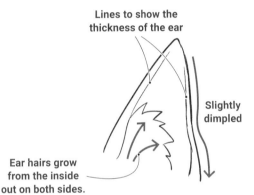

Lines to show the thickness of the ear

Slightly dimpled

Ear hairs grow from the inside out on both sides.

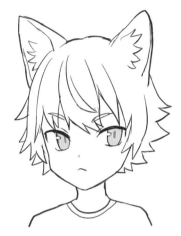

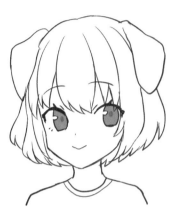

Standing ears are a feature of many types of cats, dogs and foxes.

Some dogs and rabbits have drooping ears.

Side Ears

They're attached directly to the side or are angled diagonally upward, close to the position of a human ear, making it suitable for characters with definitively human-like qualities or emotions.

Multiple Ears

By drawing both human and animal ears, both realities can be expressed at the same time. Or you can draw multiple sets of ears, depending on the character you're creating.

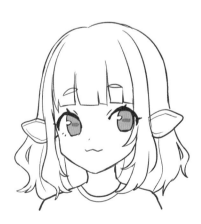

Location of the ears on sheep and cattle.

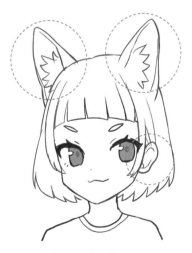

You can draw both animal and human ears depending on the character.

 ## Time to Talk Tails

An essential part of any kemonomimi character is the tail. What type of tail is best and how is it integrated into the rest of your character's design? Let's take a look!

Positioning the Tail

Like the ears, there's no exact position for the tail. For a more natural look or realistic synthesis, connect it to where the tailbone is on humans; but as always, it's up to you and the character you're conjuring!

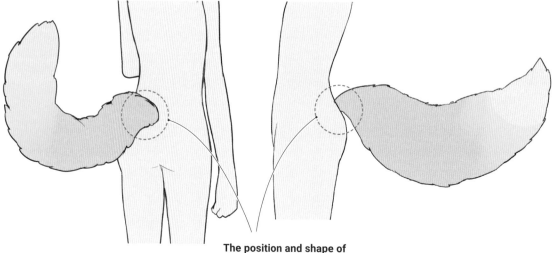

The position and shape of
tails drawn from the tailbone.

Tails in Motion

The movement of tails, which vary in size and shape depending on the animal, can be depicted in a variety of ways and express a range of emotions. The use of tails as a proxy for arms or legs is a unique feature of kemonomimi characters.

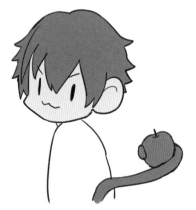

Shaking/wagging

The most popular tail movement: in motion!

Stretched out Straight

Often used to express anxiety or anger.

Prehensile Tails

Used to hold objects or to hang on to something.

Tails and Clothing

The tail is an expressive appendage and depending on the animal that inspires your character, it presents intriguing challenges when fashion and anatomy meet.

Lifting Up from Underneath

Having a tail peeking out from beneath the clothing (usually a skirt, dress or robe) lends your character a unique look and silhouette, but it presents some challenges at first when it comes to rendering the drape, flow and fold of the garment around the expressively undulating tail. Sketch out the entire tail, even the part that's concealed beneath the fabric.

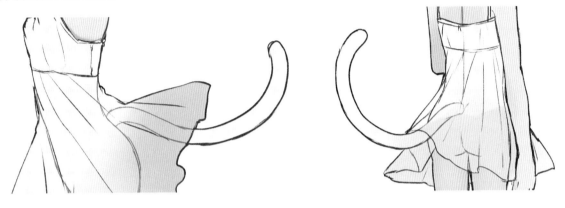

Sticking Out

A hole in the back of the garment presents another placement and positioning option, also resulting in a unique silhouette. As with tails beneath free-flowing fabrics, initially draw in its entire length, even the part that isn't visible.

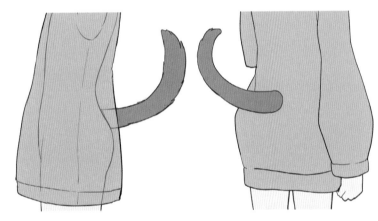

Integrated with the Clothes

Certain types of tails make the perfect design motif or fashionable embellishment. Integrating the tail into the design of the outfit is another option when it comes to tailoring the tails of your characters.

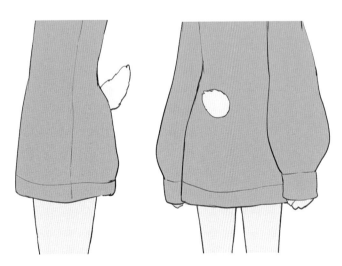

Striking Silhouettes

A character's silhouette directly affects the viewer's first impression. Applying concepts of line, shape, design and balance used in the fashion world helps integrate and embellish your character. And remember: the silhouette includes not only the clothing but also the hair and accessories.

The A Line

If the upper body is compact and more vertically oriented and the lower body has more volume, the silhouette looks like the letter A or suggests a triangle. The design can be expressed in a variety of ways, such as with a puffy skirt, a long cape, a one-piece dress that completely covers the upper half of the body and long or wide-flowing hair.

Many of the characters in this book are drawn using this basic silhouette.

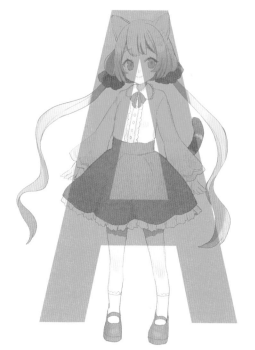

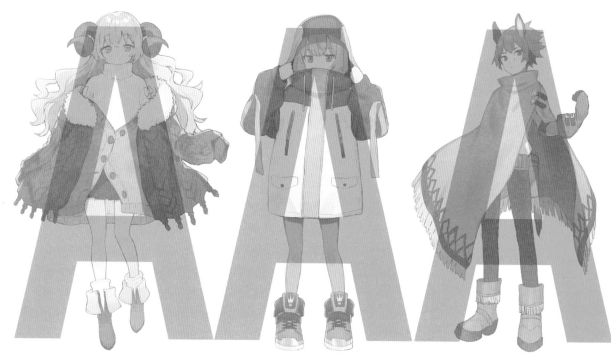

 ## The X Line

This silhouette is similar to that of the A line but is more angular and complex. The upper half of the garment can be designed to give fullness to the shoulders, while a skirt can easily be featured in the lower portion. The position of the legs also adds to the more open stance.

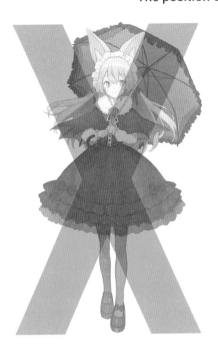

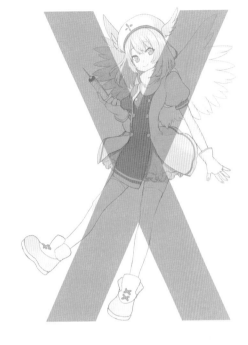

The I Line

Sleek, form-fitting clothing creates a silhouette like the letter I, yielding a stereotypically stylish or slender look. It's also a silhouette that allows for a simple, pared-down design.
This silhouette is ideal for accentuating the height and length of the character's limbs.

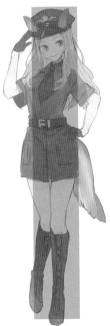

The Y Line

If the upper body is splayed or wearing a voluminous garment, while the lower body is more compactly vertical, the silhouette looks like a Y or suggests an inverted triangle. It can make the body look larger and more imposing, so it's an effective silhouette to evoke more aggressive or confrontational personas.

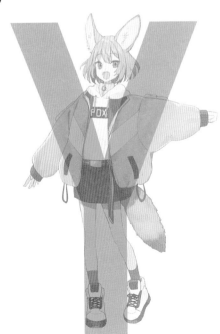

 # Character Designs

So how do you actually design a character? Here are a few suggestions and ideas. While all of the methods introduced are effective, there are no set conventions.

Three Points to Consider

The more garments and accessories you add to a character, the more distinctive and memorable they may become. On the other hand, the overall look could become cluttered or overdesigned. To streamline the character creation process, consider the following three points when developing your design.

1. Minimize what the characters wear

If you include too many fashion elements, your character design risks becoming busy or confused, standing out for the wrong reasons.

2. Have the characters wear symbolic elements

Wearing key iconic elements becomes a symbol or defining quality of the character. At this point, limit the number of elements to about two to three.

3. Design elements should be minimized and simplified.

Instead of considering what design elements to add, instead consider what is most distinctive or defining about your character and highlight that.

The version on the right may not be bad as a design, but as a character its impression is less memorable.

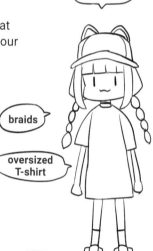

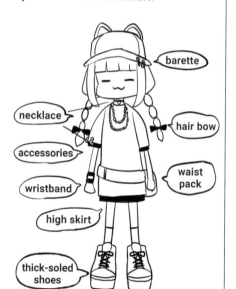

HELPFUL TIP ●

For illustrations highlighting a character's entire identity, such as for a card game or social game, having the character wear various items or placing various items on the screen can be effective. Here, overkill has its value!

Creating Characters

The animal serving as the basis for your character needs to be readily apparent. Don't make your viewers guess!

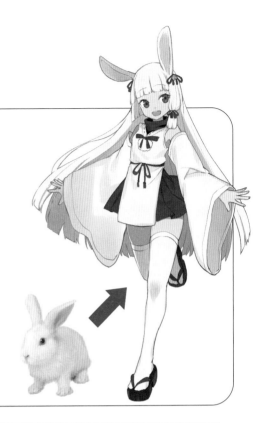

1. Refer to the animal's appearance

Design a character based on the external characteristics of the animal on which the anthropomorphism is based. This is the most standard approach, making it easiest to convey the image to the viewer:

- Incorporate animal silhouettes into hairstyles and clothing silhouettes
 For example, animals with fluffy fur can be suggested by voluminous hairstyles or faux-fur clothing.

- Utilize eye color
 Example: Siamese cats have blue eyes, Himalayan rabbits have red eyes.

- Use double teeth to represent fangs

- Use the animal's coat color in the hair and clothing (see next page)

2. Refer to each animal's personality

In addition to appearance, personality traits are just as important in design. For example, a mysterious or aloof feline character or a playful pup are stereotypical embodiments of the source animals. Strong characters spring from these associations or subvert the obvious in favor of more complex and unexpected personality pairings.

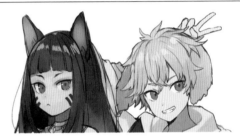

A pensive cat **A friendly, lovable pup**

3. Refer to the animal's image or connotations

For example, a Dobermann might suggest a gruff, aggressive, martial presence, so a spiky collar or army fatigues could be included, while a sheep might make a good fit as a peace-loving pacifist. Take advantage of the iconic images and common connotations associated with your choice of animal. A clarity, simplicity and directness are summoned when you reference the obvious, no matter how subtly.

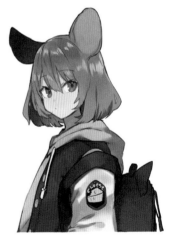

4. Refer to only one part of the animal

Isolate a single iconic element or feature associated with your animal, while making the rest of the design completely original. For example, only the ears or tail are used as identifiers, while the expression and clothing reflect a creative departure or work against type. This approach offers the most freedom in design.

The cheese logo and cheese-colored clothing are suitable for this rat-inspired character.

When Choosing Fur Color

Animals sport a range of fur colors and complex patterns. Try to include the animal's most distinctive colors or markings in only one part of the character. Specifically, the following methods can be considered.

- Add fur-like highlights to the hair.
- Include colors and patterns on the clothing.
- Incorporate markings onto the accessories.

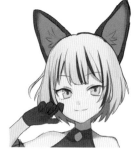

Tabby-style coloration.

You can tell at a glance what animal the character is based on.

When Designing Your Character's Outfit and Look

- Refer to the clothing of the climate, parkas for cold regions, T-shirts for hot regions
- Refer to the role of the animal and its associated images: German shepherds as police dogs, crows as witches
- Think in terms of geographical or country references, such as Japanese clothing for a Japanese deer or Egyptian clothing for an Egyptian mau
- Match the ensemble to the setting, such as autumn clothes for the harvest fair, swimsuits for vacation
- Dress the character in a uniform: maid, sailor, student
- Use the base animal itself as an accessory, as stuffed animals, hairpins, brooches or backpacks

The panda face on the hair ornament is a clear and easy way to identify the character.

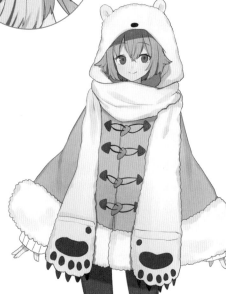

Polar bears living in the Arctic are dressed warmly.

Furry Freedoms

You're in charge of your own creation. There's no rule that says that the characteristics of the animals reflect logic or reality. In terms of design and appearance, there's no need to be faithful to every detail. For example, you can draw human ears in addition to the animal ones, exaggerate ears to make them floppy or fluffy, or draw animals eating things they don't normally consume, such as chocolate or sweets.

Finally, remember that the ears and tail aren't mere decoration but are instead key defining features, so consider their shape and function carefully when developing your character.

Designing Kemonomimi & Furry Characters

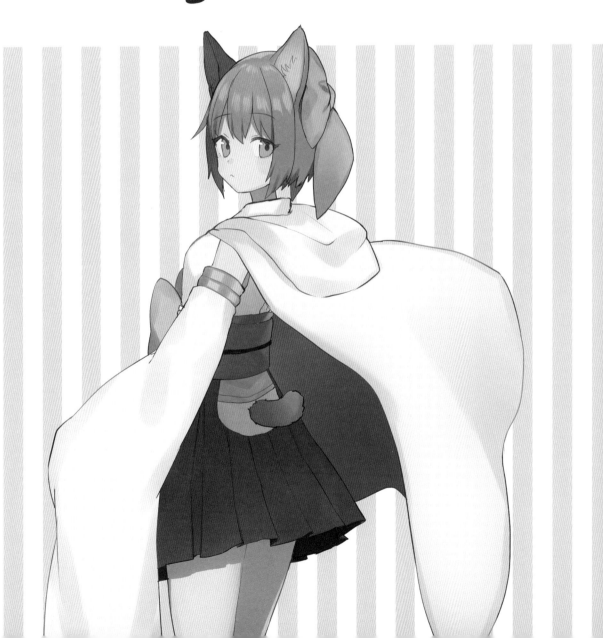

① Cats

Here, we'll design a character based on cats, trying to capture their many moods: playful, aloof, elusive and mysterious.

Characters with Cat Ears

Begin with a familiar and easy-to-adapt image of cats: capricious and cool in character and supple and slender in body. That's a strong start for character construction.

At the outer base, the ears have a pouch-like sac, which is a double layer of thin skin.

You can add fluffy tufts if you like.

The limbs can be made slightly thinner to express the supple sleekness characteristic of cats.

Front

The cute double teeth.

A long, slender, tubular tail is typical of cats. Some species have thicker or shorter versions.

Mouth Shape Patterns

Closed mouth

Opened mouth

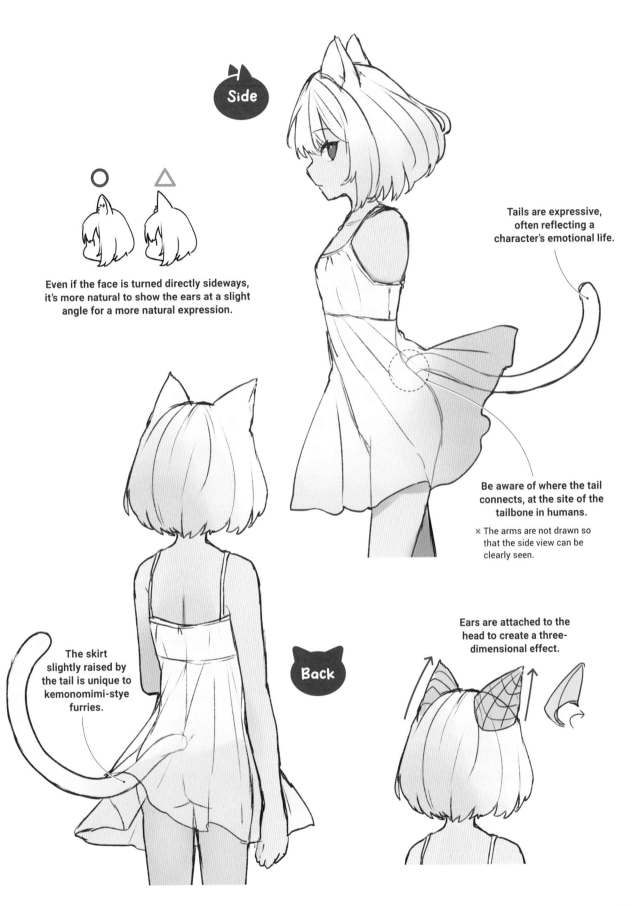

Side

Even if the face is turned directly sideways, it's more natural to show the ears at a slight angle for a more natural expression.

Tails are expressive, often reflecting a character's emotional life.

Be aware of where the tail connects, at the site of the tailbone in humans.

※ The arms are not drawn so that the side view can be clearly seen.

The skirt slightly raised by the tail is unique to kemonomimi-stye furries.

Back

Ears are attached to the head to create a three-dimensional effect.

29

Loose and Languid

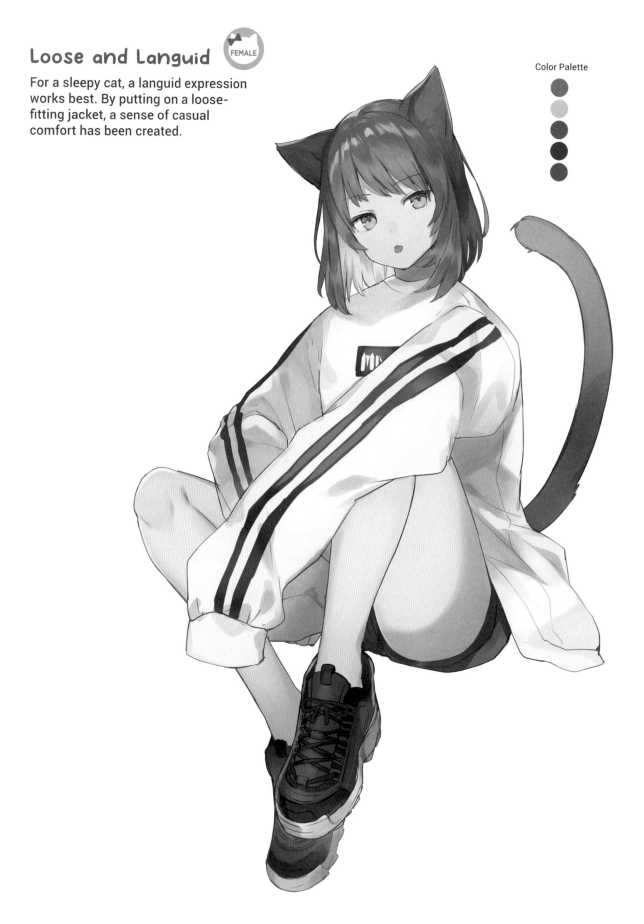

For a sleepy cat, a languid expression works best. By putting on a loose-fitting jacket, a sense of casual comfort has been created.

Color Palette

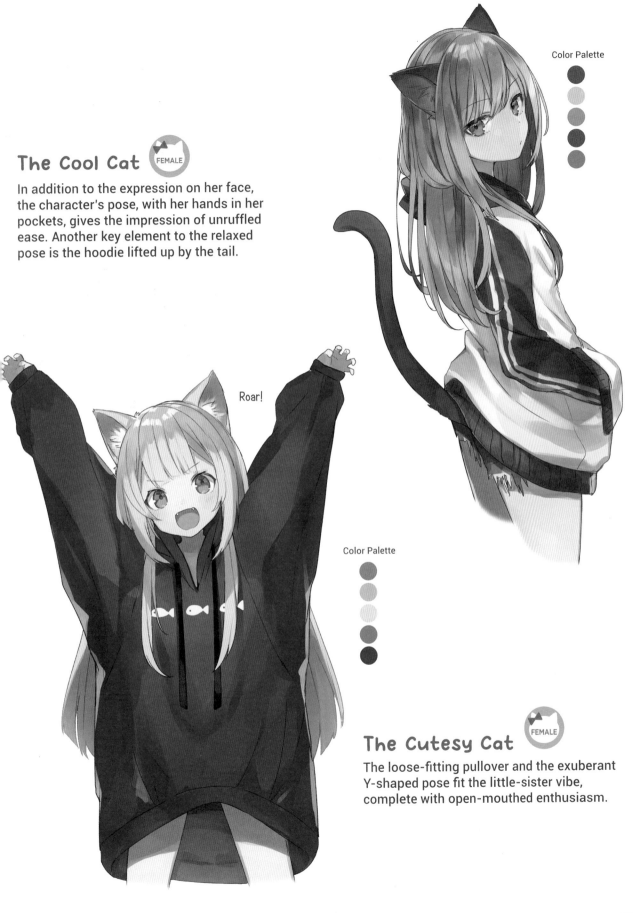

The Cool Cat FEMALE

In addition to the expression on her face, the character's pose, with her hands in her pockets, gives the impression of unruffled ease. Another key element to the relaxed pose is the hoodie lifted up by the tail.

Color Palette

Roar!

Color Palette

The Cutesy Cat FEMALE

The loose-fitting pullover and the exuberant Y-shaped pose fit the little-sister vibe, complete with open-mouthed enthusiasm.

The Casual Cat

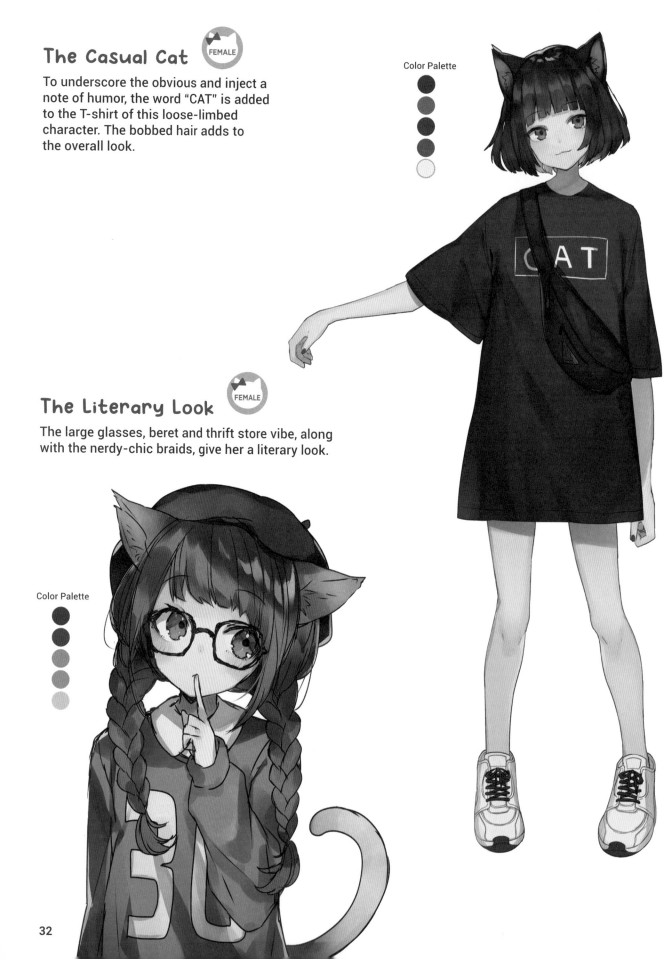

FEMALE

To underscore the obvious and inject a note of humor, the word "CAT" is added to the T-shirt of this loose-limbed character. The bobbed hair adds to the overall look.

Color Palette

The Literary Look

FEMALE

The large glasses, beret and thrift store vibe, along with the nerdy-chic braids, give her a literary look.

Color Palette

The Black Cat

FEMALE

This is an obvious if irresistible trope for a cat-based character: a little mysterious, sleekly styled, the aloofly independent type provoking curiosity.

Color Palette

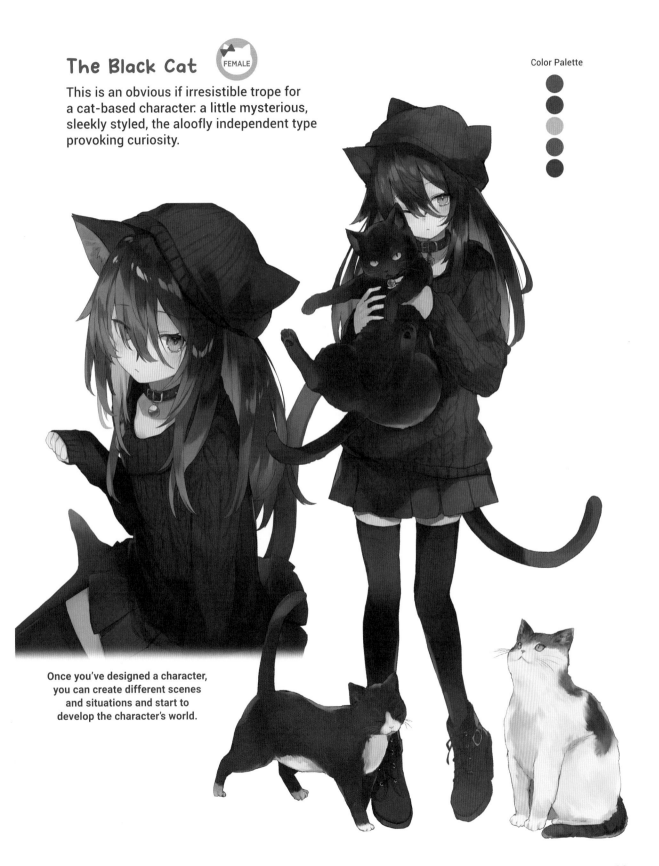

Once you've designed a character, you can create different scenes and situations and start to develop the character's world.

Cat-Based Designs

There are so many different breeds, you could spin off an endless series of feline furries. Here, we consider designs based on housecats, transforming these familiar friends into something altogether new and original.

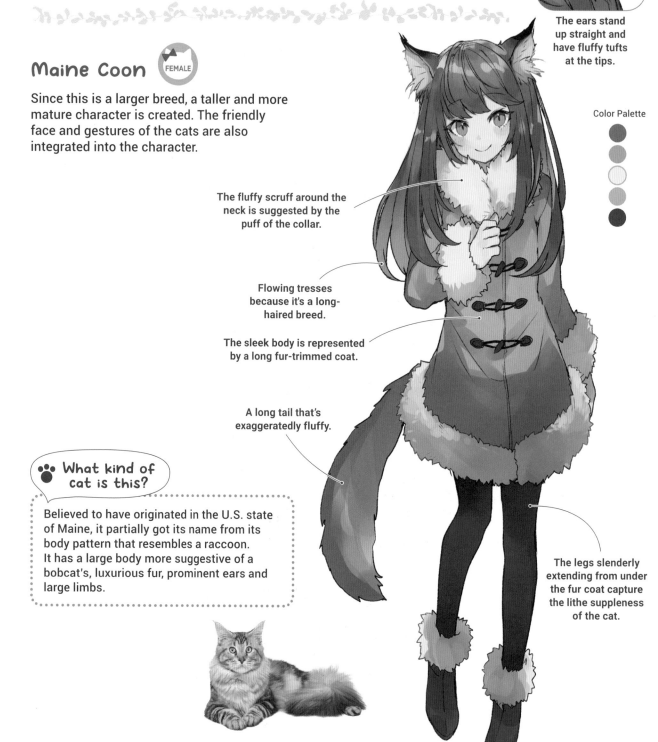

The ears stand up straight and have fluffy tufts at the tips.

Maine Coon · FEMALE

Since this is a larger breed, a taller and more mature character is created. The friendly face and gestures of the cats are also integrated into the character.

Color Palette

The fluffy scruff around the neck is suggested by the puff of the collar.

Flowing tresses because it's a long-haired breed.

The sleek body is represented by a long fur-trimmed coat.

A long tail that's exaggeratedly fluffy.

🐾 What kind of cat is this?

Believed to have originated in the U.S. state of Maine, it partially got its name from its body pattern that resembles a raccoon. It has a large body more suggestive of a bobcat's, luxurious fur, prominent ears and large limbs.

The legs slenderly extending from under the fur coat capture the lithe suppleness of the cat.

34

Scottish Folded MALE

A young boy suits this demure breed, which offers a Hail Britannia tribute in its color palette and the cableknit sweater. The distinctive customized sneakers are all his own.

Color Palette

Symbolic folded ears

The volume of the hair emphasizes the roundness of the face.

What kind of cat is this?

Intelligent, devoted companions, there are two types of Scottish folds: long-haired and short-haired, with their distinctive round faces and bodies, pronounced eyes and crooked ears.

The paw mark adds a unique detail.

The blue and white clothes and red shoes reference the colors of the British flag.

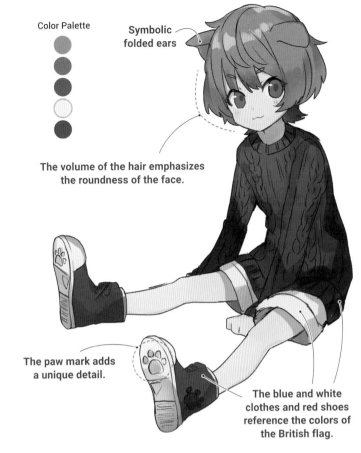

The black hair complements the palette of the clothes.

Color Palette

Abyssinian 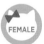 FEMALE

As the cat has short hair and a slender figure, a slim young woman with short hair is well-suited to embody this breed.

The tip of the tail is darker in color.

The clothing reflects the animal's Ethiopian origins.

What kind of cat is this?

These cats have slender bodies and eyes that are generally green or gold. Known for their curiosity, they sometimes have tabby coloration, alternating darker and lighter areas, which gives their coats a shimmering quality.

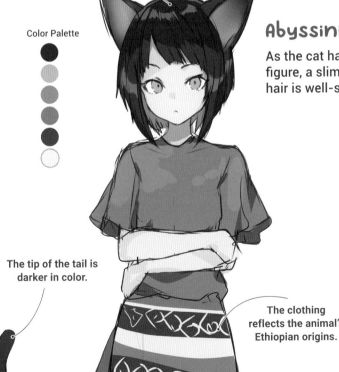

Munchkin FEMALE

Because of her short limbs and small stature, diminutive elements are the rule. The overall silhouette, including the outline of the face, is round, dimpled and childlike.

The ears are drawn slightly larger, so the body shape is emphasized all the more.

The roundness of the face is expressed by the increased volume of the hair.

The cat has short arms and legs, so her limbs are short and thick.

A clear distinction is drawn between the upper and lower body.

Color Palette

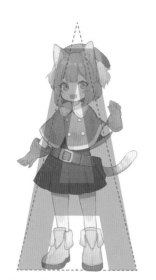

Notice the A-line or triangular shape (page 22) framing the body.

The shoes and gloves are also drawn larger in order to emphasize the petite figure.

A work belt to reflect her independent do-it-yourself spirit.

 What kind of cat is this?

With short legs and a long body, munchkins look like a feline version of a corgi or dachshund. They have walnut-shaped eyes, triangular ears and can have either long or short coats.

American Shorthair **FEMALE**

Here a little sister persona is evoked with a friendly face and sweet temperament. The frills on the blouse and skirt add to the character's soft, inviting appearance.

The typical striped pattern is represented by highlights in her hair.

The ears are neither large nor small, but just right.

The overall palette is grayish, so the eyes are made green.

The roundness of the face is enhanced by the voluminous pigtails.

Color Palette

The red of the ribbon on the chest and shoes complements the green of the eyes.

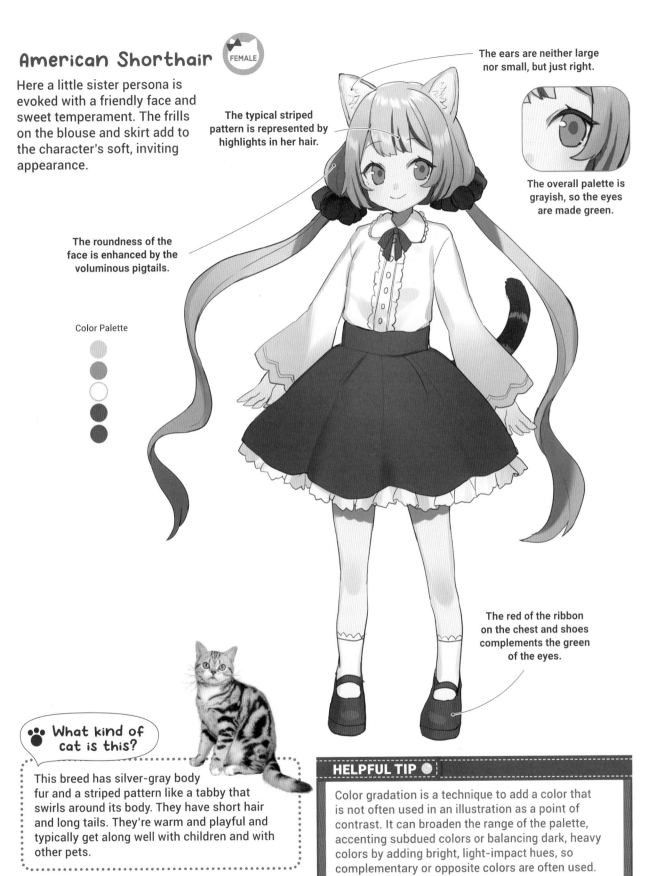

🐾 What kind of cat is this?

This breed has silver-gray body fur and a striped pattern like a tabby that swirls around its body. They have short hair and long tails. They're warm and playful and typically get along well with children and with other pets.

HELPFUL TIP ●

Color gradation is a technique to add a color that is not often used in an illustration as a point of contrast. It can broaden the range of the palette, accenting subdued colors or balancing dark, heavy colors by adding bright, light-impact hues, so complementary or opposite colors are often used.

Bombay

FEMALE

Here a slender sorceress with dark hair and a black cat has been conjured. The silhouette of the cape gives the character a unique look.

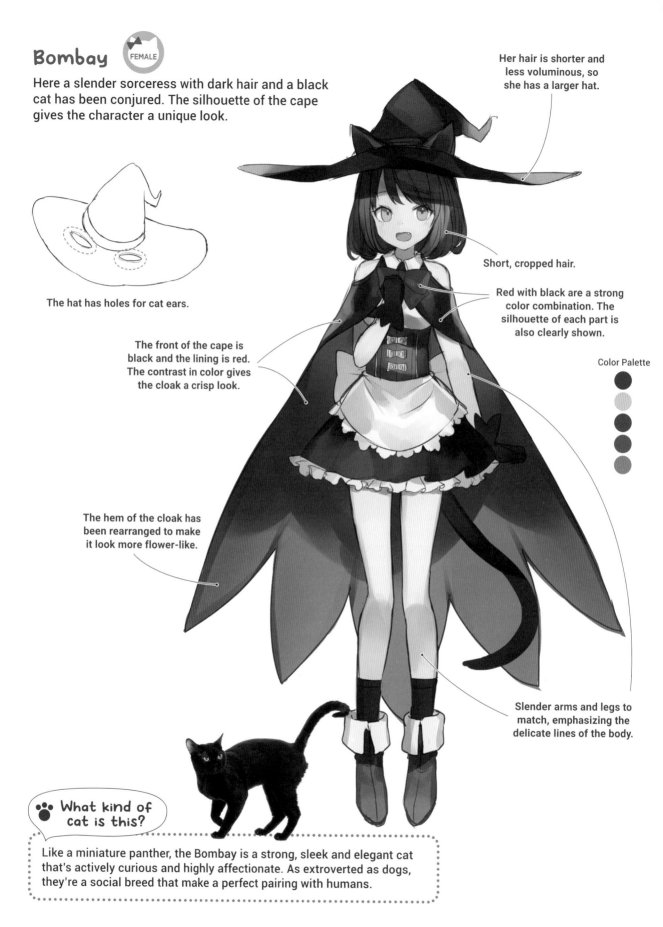

The hat has holes for cat ears.

Her hair is shorter and less voluminous, so she has a larger hat.

Short, cropped hair.

Red with black are a strong color combination. The silhouette of each part is also clearly shown.

The front of the cape is black and the lining is red. The contrast in color gives the cloak a crisp look.

Color Palette

The hem of the cloak has been rearranged to make it look more flower-like.

Slender arms and legs to match, emphasizing the delicate lines of the body.

What kind of cat is this?

Like a miniature panther, the Bombay is a strong, sleek and elegant cat that's actively curious and highly affectionate. As extroverted as dogs, they're a social breed that make a perfect pairing with humans.

Egyptian Mau

FEMALE

To suggest Egypt's hot climate, more of the body is exposed with this design, accentuated by the long, lithe legs.

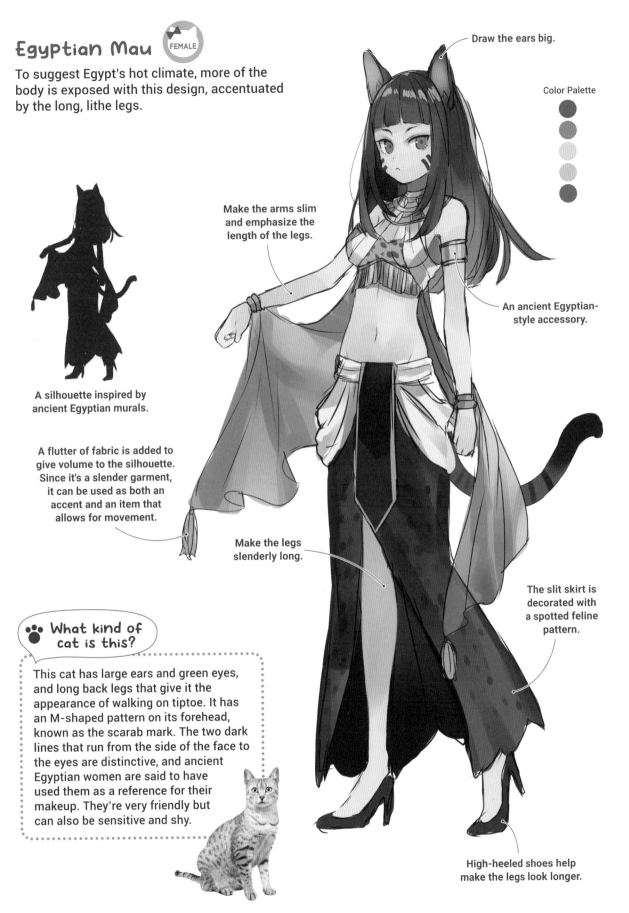

Draw the ears big.

Color Palette

Make the arms slim and emphasize the length of the legs.

An ancient Egyptian-style accessory.

A silhouette inspired by ancient Egyptian murals.

A flutter of fabric is added to give volume to the silhouette. Since it's a slender garment, it can be used as both an accent and an item that allows for movement.

Make the legs slenderly long.

The slit skirt is decorated with a spotted feline pattern.

What kind of cat is this?

This cat has large ears and green eyes, and long back legs that give it the appearance of walking on tiptoe. It has an M-shaped pattern on its forehead, known as the scarab mark. The two dark lines that run from the side of the face to the eyes are distinctive, and ancient Egyptian women are said to have used them as a reference for their makeup. They're very friendly but can also be sensitive and shy.

High-heeled shoes help make the legs look longer.

39

Siamese (Modern Style) 😺 FEMALE

Suggesting an actress or a model, this character's large ears and bright eyes lend her a dignified look, while the black elements add a more mature flair.

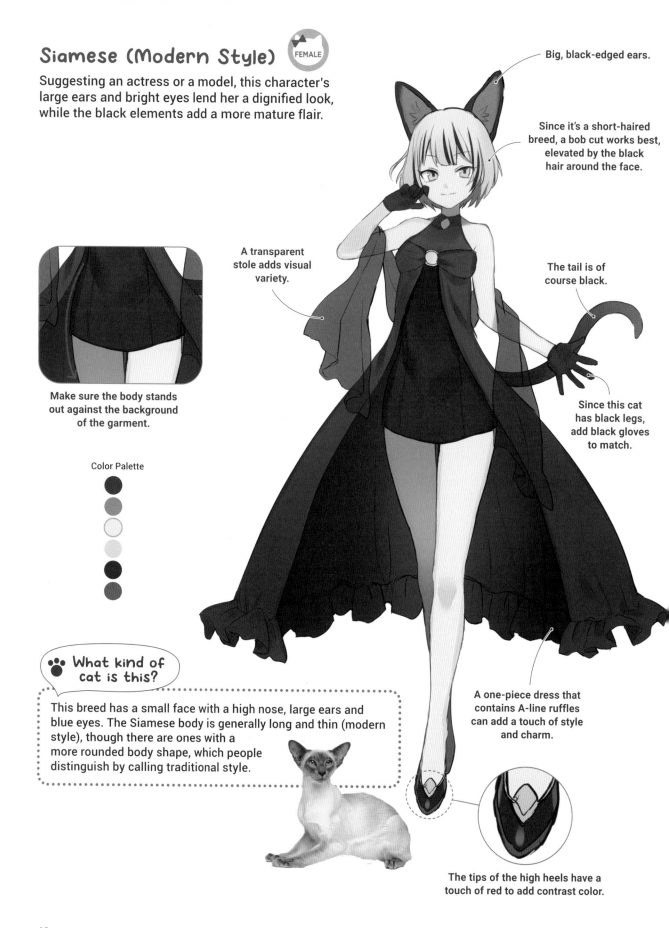

Big, black-edged ears.

Since it's a short-haired breed, a bob cut works best, elevated by the black hair around the face.

A transparent stole adds visual variety.

The tail is of course black.

Make sure the body stands out against the background of the garment.

Since this cat has black legs, add black gloves to match.

Color Palette

A one-piece dress that contains A-line ruffles can add a touch of style and charm.

😺 What kind of cat is this?

This breed has a small face with a high nose, large ears and blue eyes. The Siamese body is generally long and thin (modern style), though there are ones with a more rounded body shape, which people distinguish by calling traditional style.

The tips of the high heels have a touch of red to add contrast color.

Siamese (Traditional Style)

With a rounded body shape, in contrast to her modern style, a more youthful and exuberant character is created. To emphasize her bright and energetic persona, the character is given a summery, on-vacation look.

The same character from below. To match the aquatic theme, a sailor dress is added.

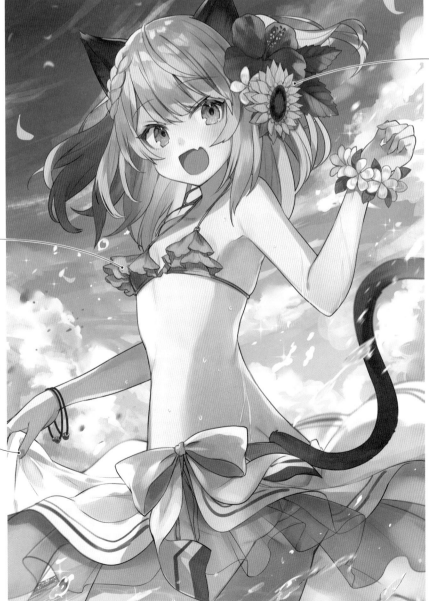

Her hair ornaments are summer-inspired flowers (from top to bottom: hibiscus, plumeria, sunflower).

The pink ruffled bikini gives her a casual look that contrasts with her more sleek, modern style.

The blue nails introduce a summery vibe.

Color Palette

41

Himalayan

FEMALE

Since this is a long-haired breed, the character is given thick flowing tresses. She's dressed in a long one-piece dress, underscoring her sense of nobility. The cat's cocoa highlights are represented by candy-like fairy tale colors.

Prominent ears in dark brown color.

The color of the hair darkens around the face to highlight her features.

The braiding shows attention to detail.

The tail is fluffy and dark brown.

The braids are fastened with ribbons.

Color Palette

The characteristic color of the cat's legs is represented by gloves and shoes in dark brown.

A chocolate-colored dress associated with sweets.

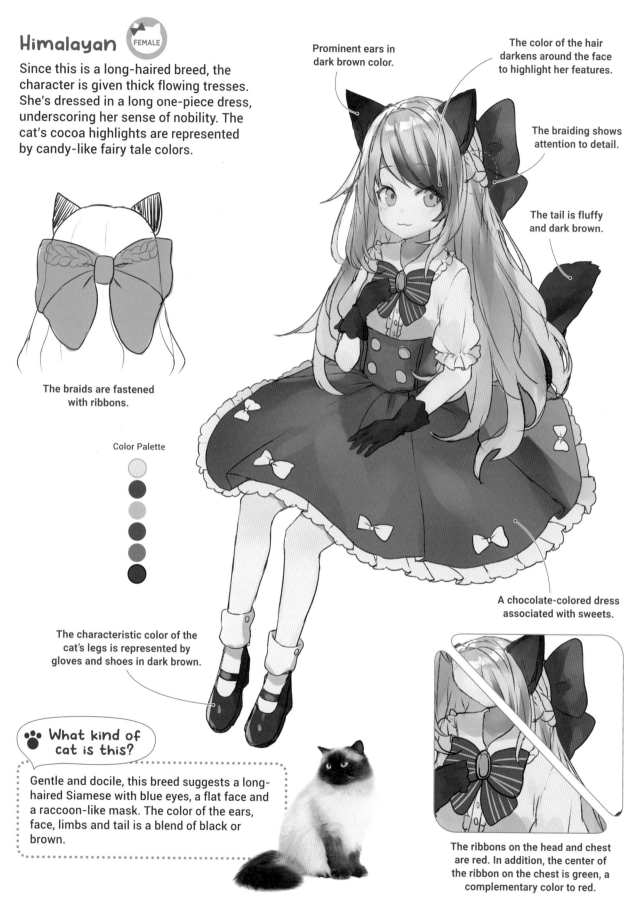

What kind of cat is this?

Gentle and docile, this breed suggests a long-haired Siamese with blue eyes, a flat face and a raccoon-like mask. The color of the ears, face, limbs and tail is a blend of black or brown.

The ribbons on the head and chest are red. In addition, the center of the ribbon on the chest is green, a complementary color to red.

Russian Blue **FEMALE**

This character is given a hint of nobility and haughty reserve. The silhouette is completely contained in a large, gorgeous cloak, the color a nod to the name of this species.

 🐾 **What kind of cat is this?**

A cat originally from Russia, it's characterized by its bluish gray fur, emerald eyes and large triangular ears. The corners of the mouth are slightly upturned, giving the appearance of a smile, thus the term "Russian smile" to describe their distinctive facial features.

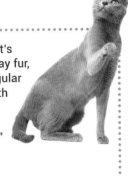

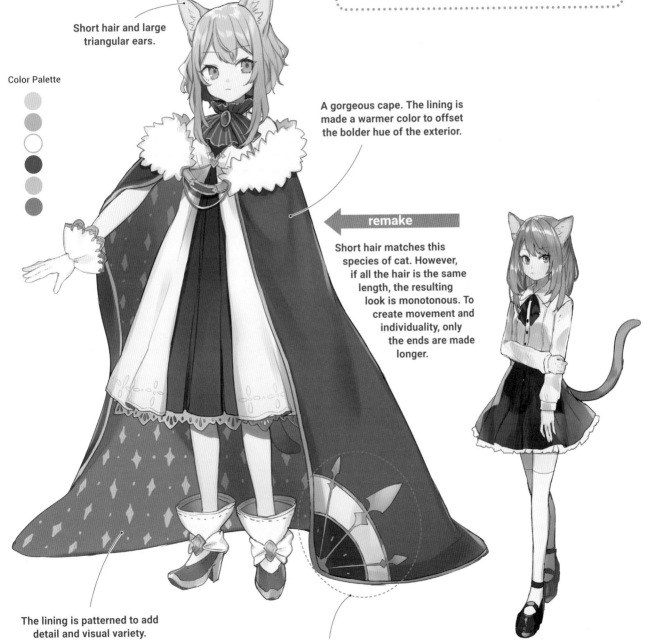

Short hair and large triangular ears.

Color Palette

A gorgeous cape. The lining is made a warmer color to offset the bolder hue of the exterior.

remake

Short hair matches this species of cat. However, if all the hair is the same length, the resulting look is monotonous. To create movement and individuality, only the ends are made longer.

The lining is patterned to add detail and visual variety.

Some embellishments are added to the flowing, dramatic cape.

Persian

The character is designed to suggest a young woman strolling in the garden of a large mansion. She's styled like an antique doll to match the Persian's prim and precious image.

The character wears a traditional bonnet.

The left and right ears are far apart and small.

Color Palette

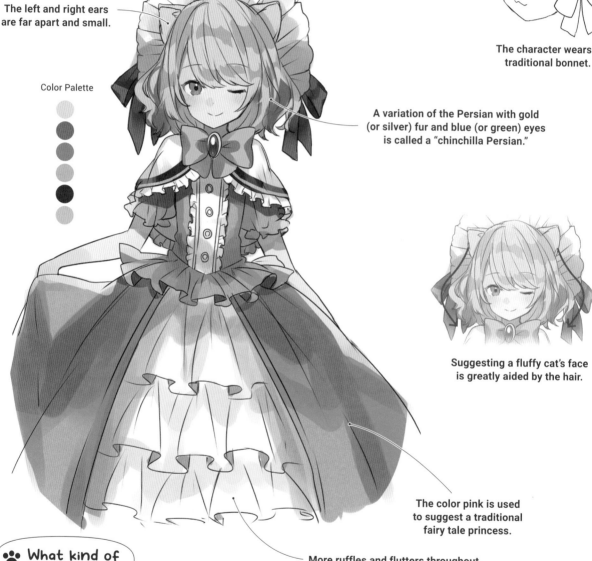

A variation of the Persian with gold (or silver) fur and blue (or green) eyes is called a "chinchilla Persian."

Suggesting a fluffy cat's face is greatly aided by the hair.

The color pink is used to suggest a traditional fairy tale princess.

More ruffles and flutters throughout.

What kind of cat is this?

This breed originated in Persia (contemporary Iran) and was brought to Europe via the Silk Road along with other valuable trade goods. It has a bushy tail and long, luxurious fur all over its body, especially around its neck.

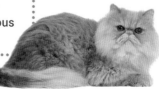

Exotic Shorthair Persian

Retro charm and frilly throwback touches give this cat character an old-fashioned appeal. Blue is used to add a sense of serenity.

Resort hats are perfect with a touch of classic, lacy fringe.

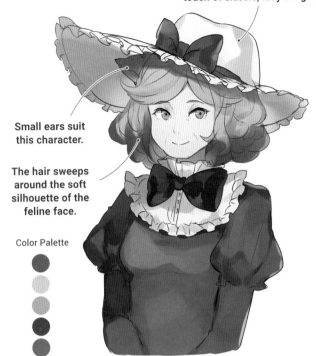

Small ears suit this character.

The hair sweeps around the soft silhouette of the feline face.

Color Palette

What kind of cat is this?

With a flat, round face and small, detached ears, they're a diminutive version of their larger Persian cousins, with laid-back personalities to match.

Because of the short hairstyle, a big ribbon creates a striking contrast.

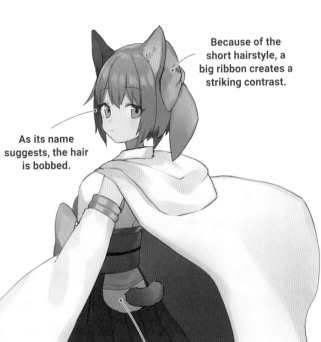

As its name suggests, the hair is bobbed.

Emphasize the tail by leaving a little space around it.

Japanese Bobtail

The Japanese-style costume highlights the characteristic tail. The main colors are the cat's white, black and brown markings while red, green and cherry blossom pink, which are inspired by wagashi (Japanese confectionery), are used as the supporting hues.

Color Palette

What kind of cat is this?

With long, lean torsos, their most distinctive feature is their very short tails. Although they're often described as having tortoiseshell markings, they come in a variety of patterns. They're highly adaptable and have gentle dispositions.

Other Cat Friends

Apart from domesticated cats, what about the more ferocious felines, the big cats that roam wild? Here, we'll consider designs based on these fierce and fabulous creatures that have evolved to survive in sometimes harsh wilderness conditions.

Black Panther

The character is designed wearing black garments that barely show the outline of the body. A large jacket is worn over a sweatshirt-style hoodie, fusing the casual with the mysterious.

🐾 **What kind of animal is this?**

This big cat's fur is not completely black; if you look closely, you can see the same spotted pattern as the panther's. They're good at climbing trees and silently sneaking up on their prey.

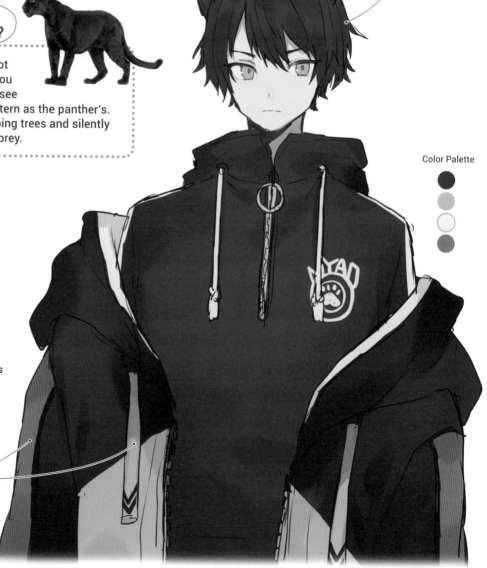

Dark, tousled hair expresses this character's wildness and individuality.

Color Palette

The hoodie's logo underscores the character's feline associations.

Black alone would yield a heavy, monochromatic look, so red and yellow are added for variety.

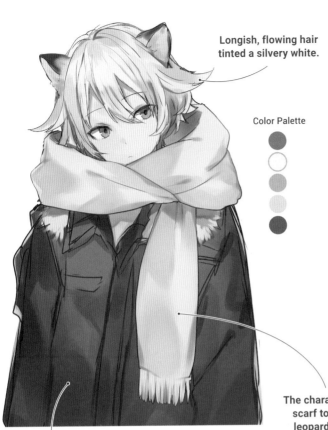

Longish, flowing hair tinted a silvery white.

Snow Leopard

Sleek and silent, this character arrives wrapped in warm layers and draped in a dramatic tail-like scarf.

Color Palette

🐾 What kind of animal is this?

Characterized by its beautiful gray coat and spotted pattern, reminiscent of snow, its limbs are thick and short in order to climb trees and scale cliffs. Their limbs are especially large, making it difficult for them to sink into the snow. Their tails can sometimes be seen wrapped around their bodies like a scarf.

The character wears a large scarf to suggest a snow leopard's sweeping tail.

He wears a military coat trimmed with fur to keep him warm in winter.

The characteristic mane is captured in the long, flowing golden tresses.

Color Palette

Lion

This character reinvents the stereotypically regal and ferocious associations that come with this big cat. Creating a sassy adolescent subverts the image further. He's wearing a souvenir jacket with a lion on his back.

The Zodiac association and frilly pink flower further downplay and soften the animal's fierce nature.

🐾 What kind of animal is this?

As the second-largest member of the cat family (after tigers), the lion has a tail with a black tuft at the tip. Only males have a mane. They're the only members of the cat family that live in groups.

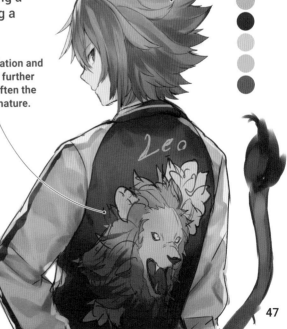

47

Lynx

FEMALE

The starting point of the design is the tufted ears. The character is designed wearing an oversized one-piece hoodie dress.

The color of the eyes is blue to balance the color of the hair and to accentuate the yellow highlights.

NE CO

Logos add an intriguing highlight, drawing viewers' attention.

Her hands inside the too-big garment indicate the character's casual nature.

👣 What kind of animal is this?

The lynx is characterized by long hairs on its face similar to those of tigers, and black ornamental hairs growing from the tips of its erect, triangular ears. Their fur is reddish and light gray in summer. In winter, it's white with brown or black spots. The species include the European lynx, Siberian lynx, Canada lynx and the bobcat.

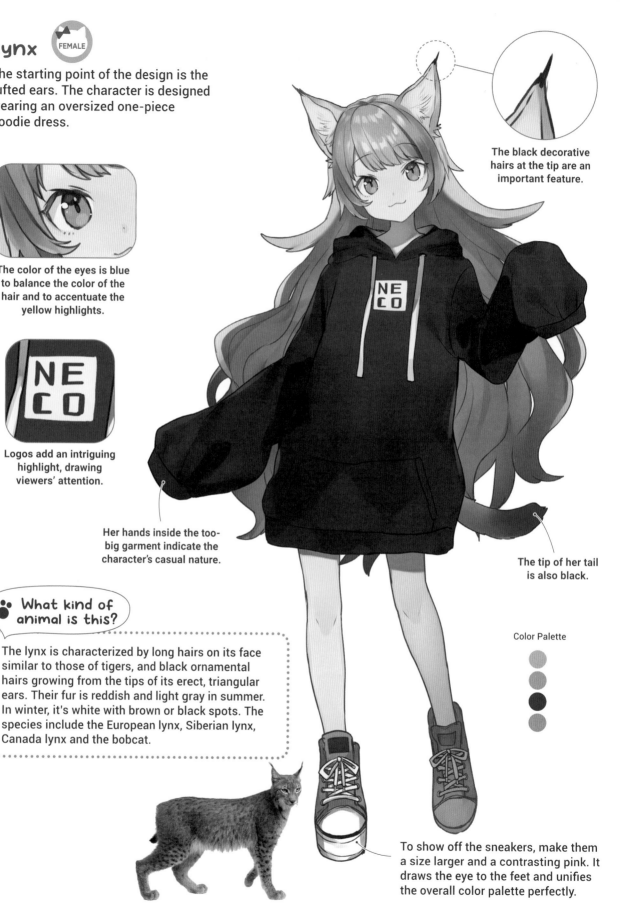

The black decorative hairs at the tip are an important feature.

The tip of her tail is also black.

Color Palette

To show off the sneakers, make them a size larger and a contrasting pink. It draws the eye to the feet and unifies the overall color palette perfectly.

Tiger 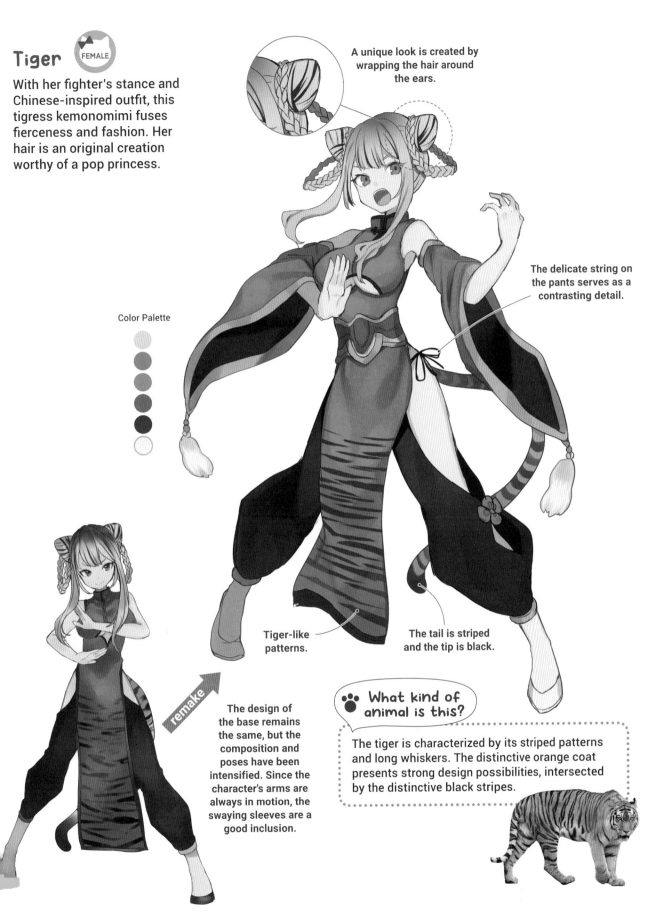 FEMALE

With her fighter's stance and Chinese-inspired outfit, this tigress kemonomimi fuses fierceness and fashion. Her hair is an original creation worthy of a pop princess.

A unique look is created by wrapping the hair around the ears.

The delicate string on the pants serves as a contrasting detail.

Color Palette

Tiger-like patterns.

The tail is striped and the tip is black.

remake

The design of the base remains the same, but the composition and poses have been intensified. Since the character's arms are always in motion, the swaying sleeves are a good inclusion.

🐾 What kind of animal is this?

The tiger is characterized by its striped patterns and long whiskers. The distinctive orange coat presents strong design possibilities, intersected by the distinctive black stripes.

Sand Cat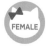

This character is given the persona of a stealthy desert thief, silently approaching on padded feet. A hooded cloak is added for concealment.

A hooded cloak helps protect against cold desert nights and sandstorms.

The long, horizontal face and hairstyle are characteristic of the sand cat.

🐾 What kind of animal is this?

An inhabitant of the deserts of Western Asia, it's characterized by its long, horizontal face and small body and triangular ears. Its fur is pale yellow with faint horizontal stripes on its sides. They also have long hair on the soles of their feet to prevent them from sinking into the desert sand.

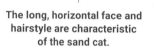

Color Palette

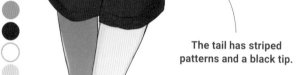

The tail has striped patterns and a black tip.

The ears are wedgelike extensions that blend into the hair.

Color Palette

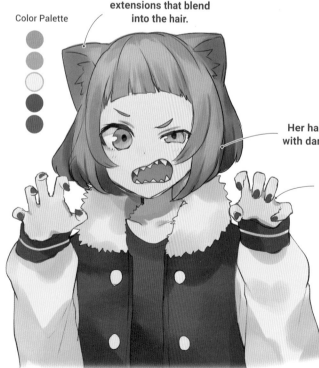

Manul (Pallas's Cat)

Manuls are characterized by their round faces and fluffy fur. This character has bobbed hair and fur around the collar. The funny expression elevates the overall design.

Her hair is bobbed with dark highlights.

Red nails add a note of contrast.

🐾 What kind of animal is this?

Manul means "little bobcat" in Mongolian. It has long, whisker-like hair on its cheeks and a striped tail with a black tip. Thanks to their long body hair, they don't get cold even when lying on the frozen ground.

Cat Facial Expressions

Combining the facial expression with the position and motion of the distinctive ears presents a wealth of possibilities when animating your feline furries' faces.

Happy

Calm contentment infuses the face. The eyes are slits, the rosy cheeks underscoring the character's ease and contentment.

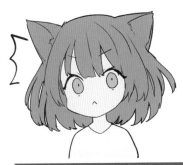

Surprised

The eyes are wide open, the pupils are small and the mouth is a small slash to create an expression of surprise. At the same time, the ears can be pinned up or the tail can be turned back.

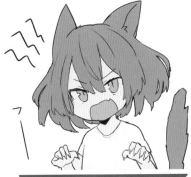

Angry

The eyes and eyebrows are close together to give the impression of being lifted up. Add a wrinkle between the eyebrows. The tail is stiff, and the claws are out, expressing anger with the whole body.

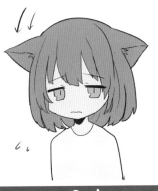

Sad

The ears are drooping, and the hair is wispy. The eyebrows and eyes are similarly downcast. The tail can be hanging down slackly too.

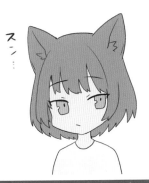

Disinterested

The face is almost expressionless, and the eyes are averted to suggest a cat's sometimes aloof or distracted nature.

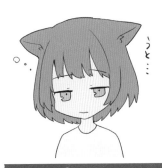

Sleepy

The ears are turned down and the eyes are downcast. The mouth is also made to look relaxed.

② Dogs

Dogs are popular partners, and it's not surprising why. Here, we'll design a cast of characters based on dogs.

Characters with Dog Ears

Energetic, active and friendly is the image many people associate with dogs. Since appearance varies from breed to breed, we have anthropomorphized a dog with drooping ears and a tail that curves smoothly upward.

Ears should be drawn following the shape of the head.

Front

Shape of the Mouth

The two protruding teeth aren't too long, to differentiate from a wolf's.

Open mouth + double teeth

Rounded tips help distinguish these characters from those based on cats.

Types of ears

Folded ears

Drooping ears
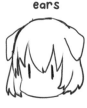

Pointy ears

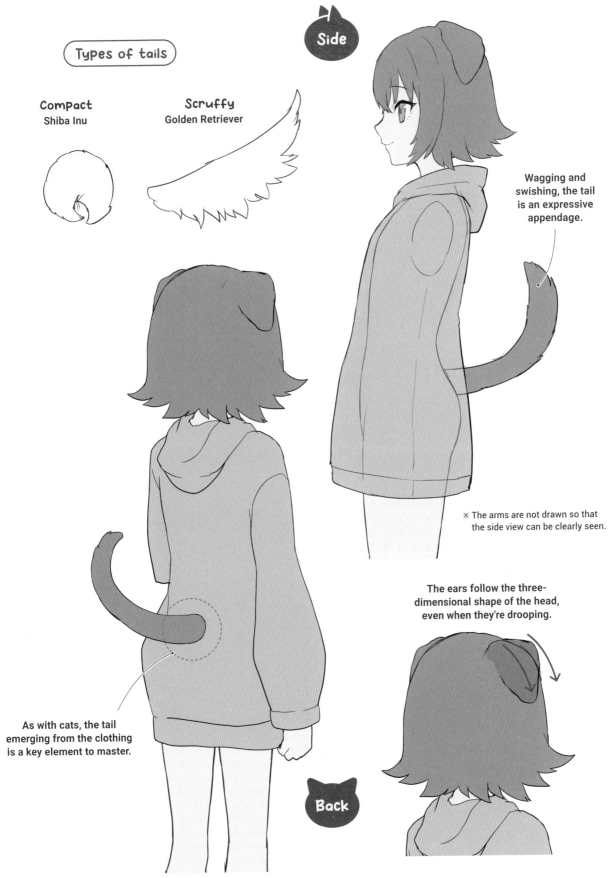

Types of tails

Compact
Shiba Inu

Scruffy
Golden Retriever

Side

Wagging and swishing, the tail is an expressive appendage.

✕ The arms are not drawn so that the side view can be clearly seen.

As with cats, the tail emerging from the clothing is a key element to master.

Back

The ears follow the three-dimensional shape of the head, even when they're drooping.

Komainu (Lion-dog) Style

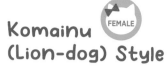

Komainu, often called lion-dogs in English, guard the entrances to Shinto temples. The character's ensemble is based on miko, or shrine maiden, outfits, with the bare shoulders and dramatically flowing sleeves.

Color Palette

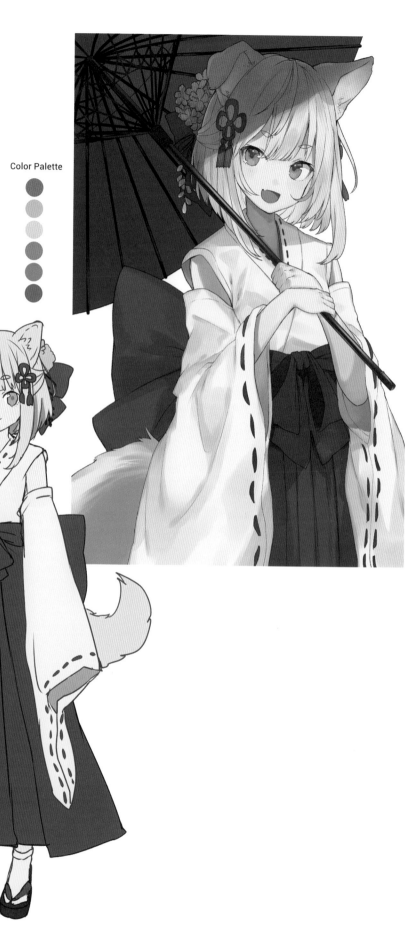

Half updo hair

The Chinese Zodiac FEMALE

The design is based on the Chinese zodiac sign. White fur and a red haruegi-gai (or formal kimono) and good luck charms further elevate the illustration.

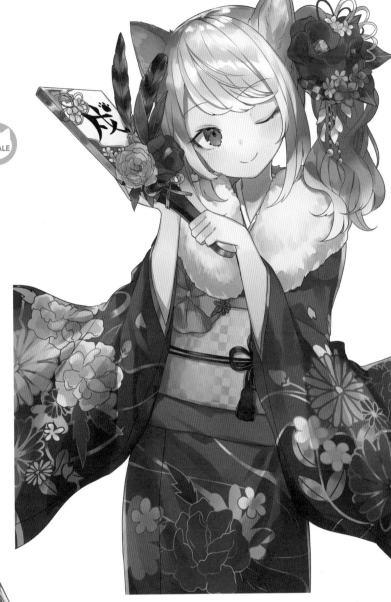

Color Palette

The Hungry Dog FEMALE

A girl with dog ears eating a steamed meat bun. Since dogs are known for their voracious appetites, show your character savoring a snack or chowing down canine-style.

Dog Ear Designs

If there's anything we love as much as cats, it's dogs. They come in so many shapes and sizes, irresistible fodder for any furry or kemonomimi artist. Here are just a few ideas for canine-inspired character creations. Find your own direction and run with it!

Dachshund FEMALE

The image of a treasure hunter comes to mind, searching for riches. The goggles, pouch and rope, along with the jacket and fringed shorts, add to the character, highlighting her boundless energy and curious nature.

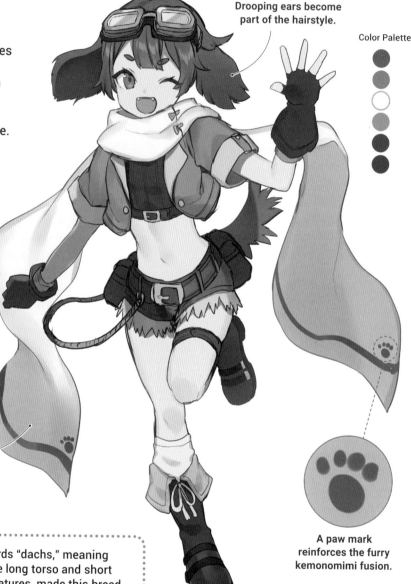

Drooping ears become part of the hairstyle.

Color Palette

Since this dog has a long, slender torso, the silhouette around the waist is emphasized.

A long scarf helps show movement. It also creates a wider silhouette.

🐾 **What kind of dog is this?**

Its name comes from the German words "dachs," meaning badger, and "hund," meaning dog. The long torso and short legs, which are its most distinctive features, made this breed an effective a hunting dog. With long muzzles and drooping ears, there are three types of body hair: short smooth haired, soft and long haired or long and wiry haired.

A paw mark reinforces the furry kemonomimi fusion.

Large work boots perfect for a treasure hunter's treks.

Border Collie FEMALE

A shepherdess is the perfect persona for a sheepdog-inspired character. The dog has fluffy ears and an upward-curling tail, so be sure to include these two features.

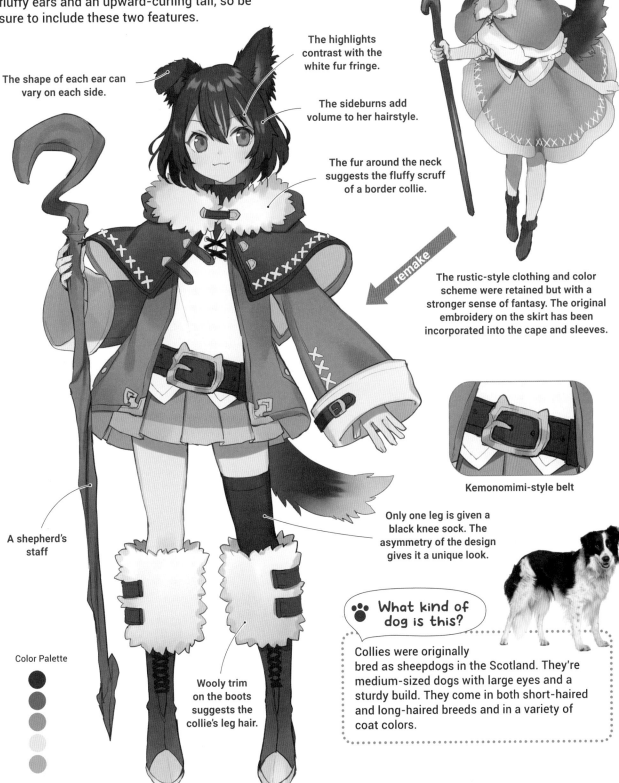

The shape of each ear can vary on each side.

The highlights contrast with the white fur fringe.

The sideburns add volume to her hairstyle.

The fur around the neck suggests the fluffy scruff of a border collie.

remake

The rustic-style clothing and color scheme were retained but with a stronger sense of fantasy. The original embroidery on the skirt has been incorporated into the cape and sleeves.

Kemonomimi-style belt

A shepherd's staff

Only one leg is given a black knee sock. The asymmetry of the design gives it a unique look.

Color Palette

Wooly trim on the boots suggests the collie's leg hair.

What kind of dog is this?

Collies were originally bred as sheepdogs in the Scotland. They're medium-sized dogs with large eyes and a sturdy build. They come in both short-haired and long-haired breeds and in a variety of coat colors.

Borzoi FEMALE

The borzoi-based character is designed wearing a faux-fur hat with ear flaps on it. Her garments and hair color suggest a borzoi's.

The eyes are light reddish brown so they'll stand out more.

Ears that can be shaken to create a sense of movement.

The poncho's fluffy fur suggests the borzoi's coat.

Her long hair also references the borzoi's shaggy coat.

Color Palette

HELPFUL TIP

Sometimes it's best to attach the ears directly to a hat or headpiece, styling them as a natural extension of the garment.

Decorations based on a borzoi's ears.

Don't forget the highlights on the tail.

The dark tights accentuate the long, slender legs

What kind of dog is this?

The borzoi has a sleek, yet muscular build with long limbs, a long mouth, a slender small head and drooping ears. Its body coat is long and slightly wavy, giving it a graceful appearance. It has long hairs on its chest, on the back of its limbs, and on its tail.

Poodle

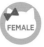
FEMALE

A frilly, beribboned young woman with twin ponytails is the perfect embodiment of a toy poodle's soft and delicate associations.

Groomed and self-regarding, the character's vanity is revealed in her hand mirror.

The eyes are dark and round like buttons.

Numerous ribbons emphasize the character's soft and prim cuteness.

Fluffy drooping ears are represented by twin ponytails.

The twin ponytails, which are designed to resemble ears, are now neatly styled.

remake

The garment is pink, with many frills attached.

Color Palette

What kind of dog is this?

This popular pet is divided by size, with the toy poodle being the largest and the standard poodle the smallest. They're characterized by their fluffy drooping ears and sometimes curly body hair. The coat color is basically monochromatic, but it can be varied.

German Shepherd FEMALE

A police officer with a confident and easygoing expression suits the embodiment of a breed associated with law and order.

 Large ears that rarely droop.

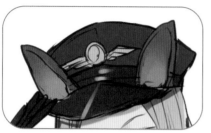

The hat is structured so that the ears protrude. The brim is inspired by the black hairs around a shepherd's nose.

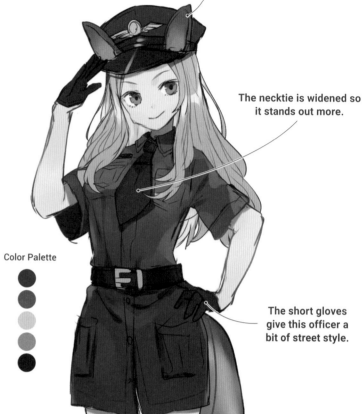

The necktie is widened so it stands out more.

The short gloves give this officer a bit of street style.

The shepherd's strong, agile legs are highlighted by the design.

Color Palette

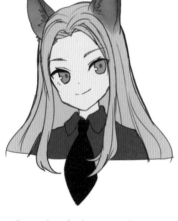

Sweeping the bangs to the sides and showing the forehead yields a more mature look.

🐾 What kind of dog is this?

Muscular with a gently sloping body along its back to its tail, they have prominent ears and a bushy tail. They come in both short-haired and long-haired varieties, and their coat color varies, but they all have a black mask that extends around the nose. Because of their physical characteristics and personality, they're widely used as police and military dogs and as part of canine units.

Dobermann FEMALE

It's not surprising that this Goth/punk-inspired design centers on black as its base color. The ears are a prominent feature, further extending the long line of the body.

Distinctive pointed ears.

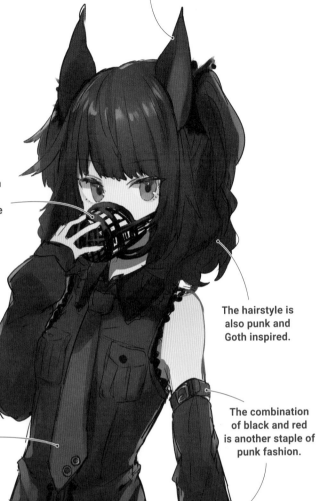

The muzzle's an edgy addition, emphasizing the punk look.

Color Palette

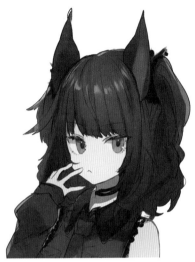

Without the muzzle

The Goth/punk-style red tie is both a fashion statement and an accent color.

The hairstyle is also punk and Goth inspired.

The combination of black and red is another staple of punk fashion.

 What kind of dog is this?

This breed has a strong jaw and a thin, muscular build. It's covered with smooth, short body hair. Its pointed ears and very short tail are also its distinguishing features. Like the German shepherd, the Dobermann is widely used as a police and military dog as part of canine units.

Shiba Inu

This classic Japanese breed has here been transformed into a young man in a student uniform from the Meiji/Taisho era. The character's palette is based on a black-haired Shiba Inu instead of a brownish red-haired one.

A mushroom cut captures the breed's dark crown.

Small erect ears match the face.

The key point is to draw short eyebrows, to match the facial patterning of a Shiba Inu.

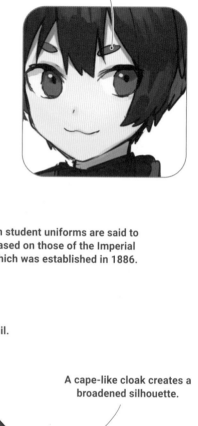

All black would make the design heavy and monochromatic. Red and yellow are added to the cap to create contrast.

Many modern student uniforms are said to have been based on those of the Imperial University, which was established in 1886.

The white gloves give him a military vibe.

A curly tail.

A cape-like cloak creates a broadened silhouette.

Color Palette

What kind of dog is this?

A popular breed from Japan, it has small ears and a thick curly tail. They have short body hair, and their coat color varies widely. Originally bred as a hunting dog, they're prized pets for being smart and independent.

Golden Retriever MALE

Here a golden retriever is transformed into an energetic boy who seems to get along with everyone. His casual street-style fashion adds to the image.

If the hair is too long, it'll obscure the eyes and face, so a short style works best.

🐾 What kind of dog is this?

The much-loved retriever family has almond-shaped eyes and drooping ears. The coat color is shiny gold or cream. The front of the body, the chest and abdomen, the backs of the limbs and the tail are covered with long, fluffy hair.

Keep the clothes simple to show off the bushy, droopy ears.

remake

DOGTOOTH

A logo that suggests an athletic or sports brand.

Color Palette

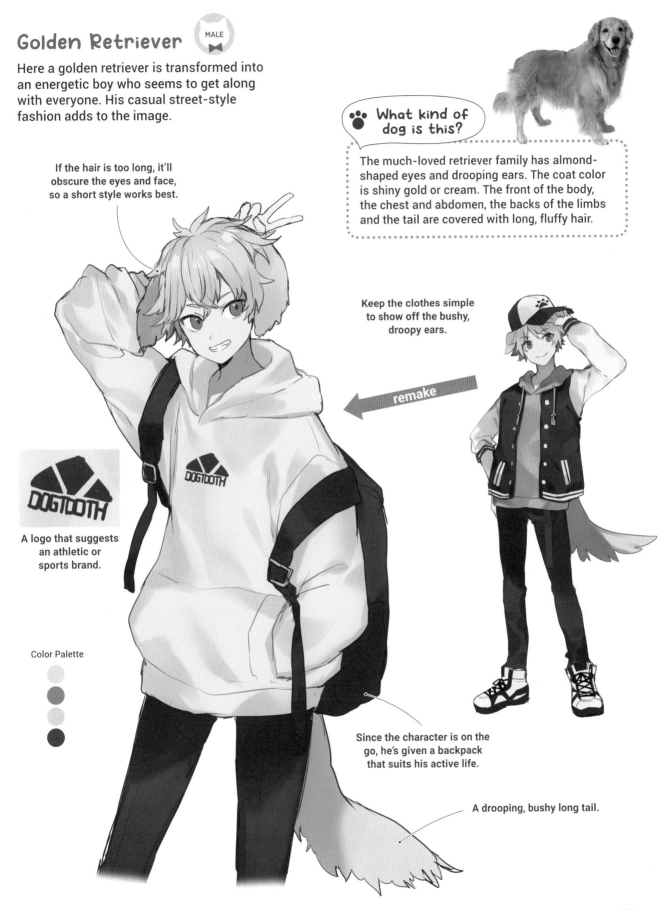

Since the character is on the go, he's given a backpack that suits his active life.

A drooping, bushy long tail.

Japanese Spitz MALE

This character is designed to look like a butler serving a foreign aristocrat. Have fun with it, adding soft, fluffy elements throughout the design.

The ears are triangular and small.

Make the hair full-bodied and voluminous.

 What kind of dog is this?

This breed has pointed ears, a bushy voluminous tail and large almond-shaped eyes with a slight droop at the corners. Its body fur is long and fluffy, and the coat color is pure white.

Color Palette

Adding gold ornaments to the tailcoat makes it look luxurious and also heightens the sense of fantasy.

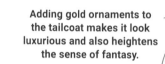
remake

The shorts were kept and the boyish look retained, but more details and formal elements are added.

The lining is red as an added highlight.

The long socks give him a more juvenile look.

Siberian Husky MALE

This cool character is created with a crisply drawn face and twinkling eyes. Since this is a dog associated with colder climates, the character is given a warm down jacket.

Wolf-like ears that perk up when on alert.

The hood is fluffy while the hair is neat and tidy.

Crisply drawn eyebrows

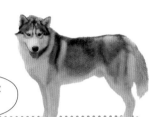

🐾 **What kind of dog is this?**

This breed originates from the Siberian region of Russia. Famously used as a sled dog to transport Inuit across the frozen northern plains, their eyes come in a variety of colors.

Color Palette

The tail is long and fluffy.

A voluminous two-sided updo and drooping ears.

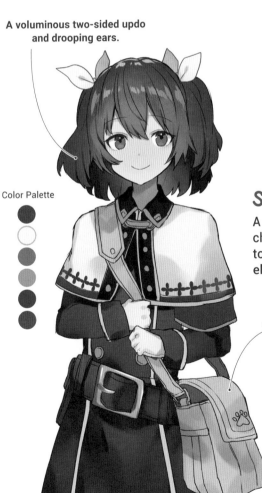

Color Palette

St. Bernard FEMALE

A fantasy-style medic or medical professional suits a character based on this breed. Since its ancestors are said to have been military dogs, the figure displays some military elements, such as a uniform dress and an armband.

A first aid bag conjures the image of a rescue dog.

🐾 **What kind of dog is this?**

The name comes from the monastery of Saint Bernard in the snowy Alps, which straddle Italy and Switzerland. The Saint Bernard has a large build, drooping ears and a thick tail with a slightly curled tip.

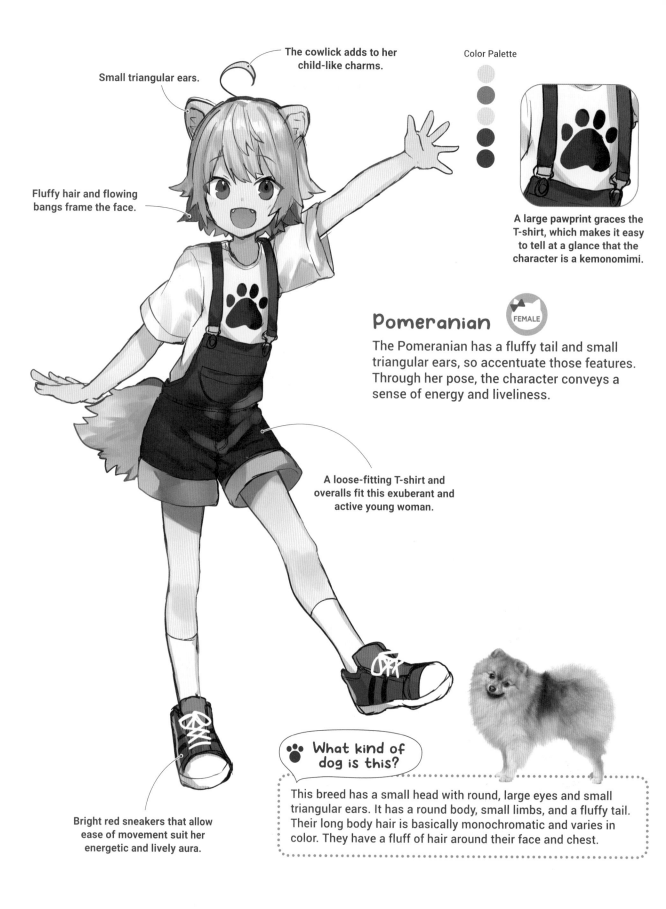

The cowlick adds to her child-like charms.

Small triangular ears.

Fluffy hair and flowing bangs frame the face.

Color Palette

A large pawprint graces the T-shirt, which makes it easy to tell at a glance that the character is a kemonomimi.

Pomeranian

FEMALE

The Pomeranian has a fluffy tail and small triangular ears, so accentuate those features. Through her pose, the character conveys a sense of energy and liveliness.

A loose-fitting T-shirt and overalls fit this exuberant and active young woman.

Bright red sneakers that allow ease of movement suit her energetic and lively aura.

What kind of dog is this?

This breed has a small head with round, large eyes and small triangular ears. It has a round body, small limbs, and a fluffy tail. Their long body hair is basically monochromatic and varies in color. They have a fluff of hair around their face and chest.

Chihuahua FEMALE

The key points in the design are the hair, which is slightly wavy and fluffy, and the dark, rounded eyes. The chihuahua is a shy dog, so the character can channel these qualities as well.

Large ears that angle outward.

Don't forget the bushy hair under her ears.

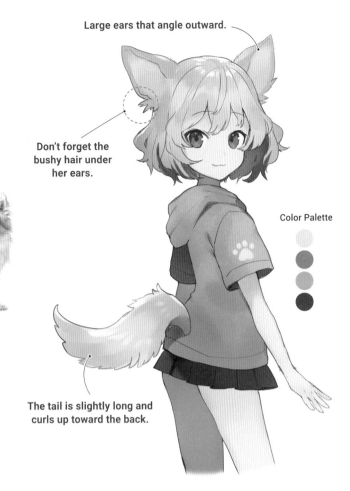

Color Palette

What kind of dog is this?

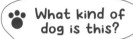

These tiny pets have large, round eyes and a round, apple-shaped head. They come in two types: short haired and long haired. They're cheerful and active and due to their size are popular as urban pets.

The tail is slightly long and curls up toward the back.

The tips of the ears are rounded.

Color Palette

Pembroke Welsh Corgi FEMALE

I love Corgi's curvy buttocks so I decided to pose her in a way that emphasizes this feature. The character is designed to be sporty and exuberant, always up for fun.

The shorts emphasize the buttocks.

What kind of dog is this?

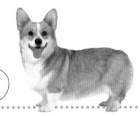

Corgis have outsized ears, almond-shaped brown eyes, long torsos and short legs. A short-haired breed, its coat color is ruddy, sable, fawn, black or light brown.

Since it's a short-legged breed, the thighs are given more bulk.

Other Dog Friends

There are many canine species that can inspire an array of funny or fierce furry and kemonomimi characters. Before we look at wolves and foxes, let's examine a design inspired by the elusive raccoon dog.

Raccoon Dog

FEMALE

The image of an ascetic monk on a journey is suggested by the traditional, wide-brimmed hat. The kimono she's wearing is a bit ornate, inspired by Taisho romanticism. However, the rest of the ensemble is a bit more subdued. The hakama and haori are simple and dull in color to keep a balance.

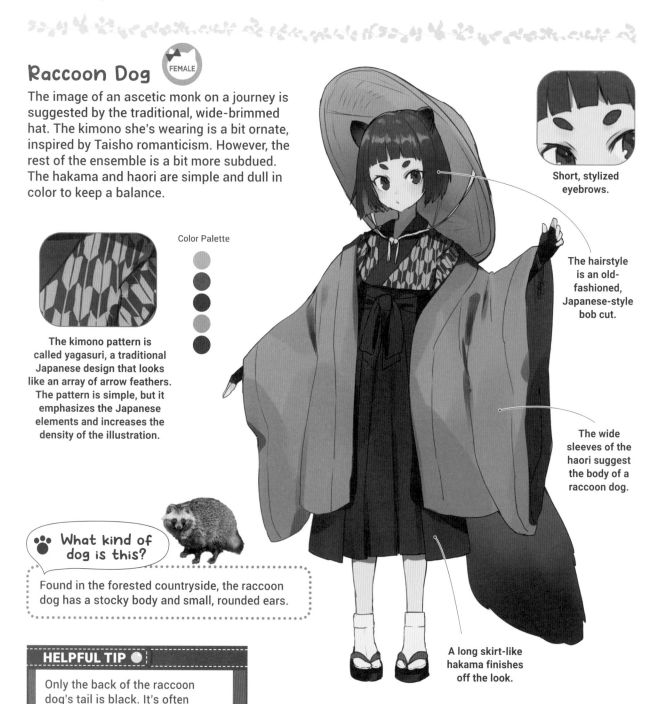

Color Palette

The kimono pattern is called yagasuri, a traditional Japanese design that looks like an array of arrow feathers. The pattern is simple, but it emphasizes the Japanese elements and increases the density of the illustration.

Short, stylized eyebrows.

The hairstyle is an old-fashioned, Japanese-style bob cut.

The wide sleeves of the haori suggest the body of a raccoon dog.

A long skirt-like hakama finishes off the look.

🐾 What kind of dog is this?

Found in the forested countryside, the raccoon dog has a stocky body and small, rounded ears.

HELPFUL TIP ●

Only the back of the raccoon dog's tail is black. It's often mistaken for stripes. Be sure not to confuse it with a raccoon!

Dog Facial Expressions

Dogs use their ears, tails and facial features to communicate and express their emotions. Each breed has different ears and tails, so it's easy to create variations.

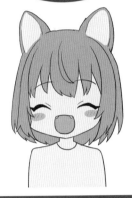

Happy

The mouth is wide open and the eyes are curvier than a feline's.

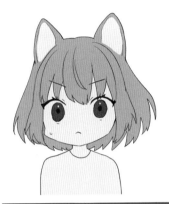

Frightened

The eyes are wide open, the ears erect and the hair suggests it's standing on end.

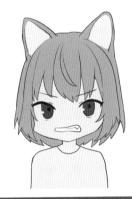

Angry

Dogs reveal their anger by baring their teeth and growling. The ears should be pointed at the source of the irritation.

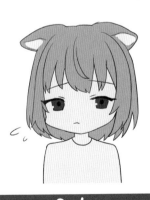

Sad

The ears should be tucked in. The outer sides of the eyebrows and eyes should be tilted down. The tail should also be lowered.

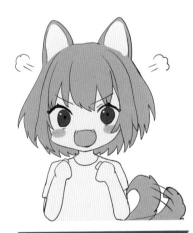

Excited

The image is a combination of pleased and surprised. Wagging the tail conveys the excitement. You can also point the character's ears toward the source of excitement.

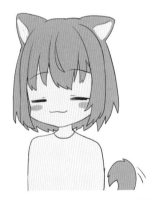

Relaxed

An expression suggesting peace and ease. Ears are slack and relaxed, and the tail wags slowly. The expression on the face is relaxed and mellow.

69

③ Foxes

Sly, slinky and mysterious, while also wary and playful, foxes present a range of transformative possibilities when creating furry and kemonomimi characters.

Characters with Fox Ears

Here, a Japanese-style character dressed in a miko, or shrine maiden, outfit is brought to life. The fluffy tail is an important and impactful finishing touch.

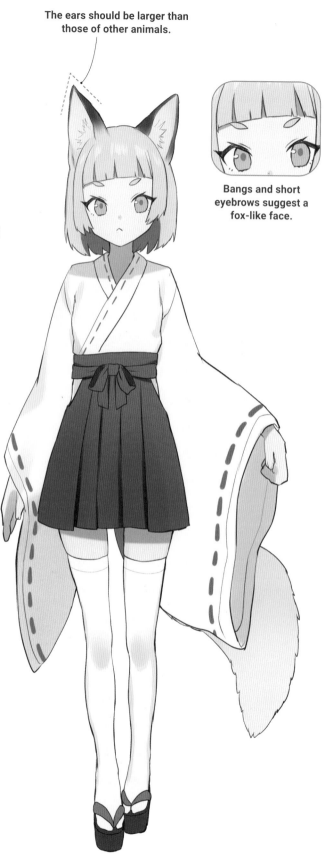

The ears should be larger than those of other animals.

Bangs and short eyebrows suggest a fox-like face.

Front

The Shape of the Ears

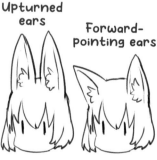

Large ears

Upturned ears

Forward-pointing ears

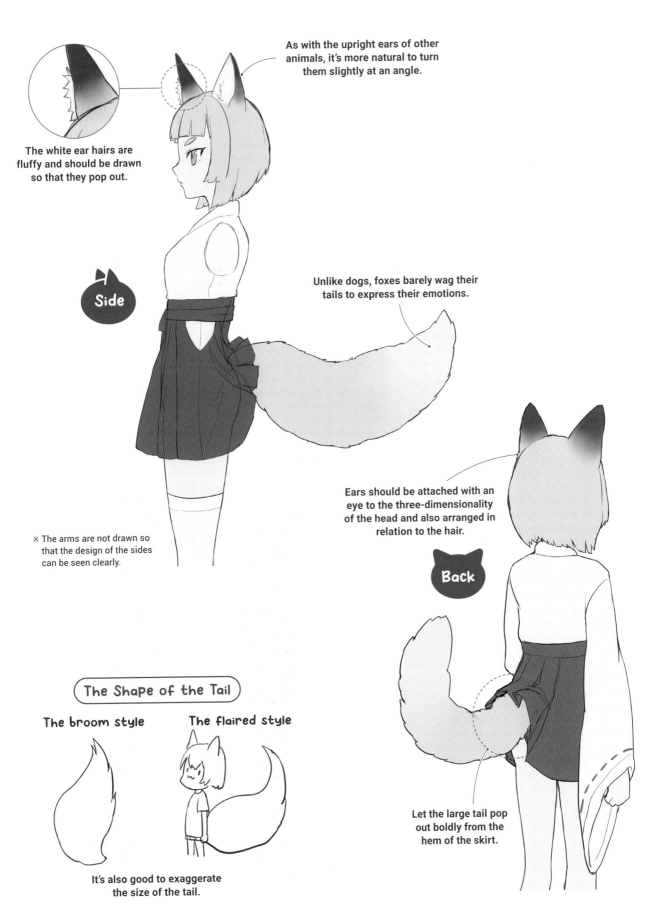

The white ear hairs are fluffy and should be drawn so that they pop out.

As with the upright ears of other animals, it's more natural to turn them slightly at an angle.

Side

Unlike dogs, foxes barely wag their tails to express their emotions.

※ The arms are not drawn so that the design of the sides can be seen clearly.

Ears should be attached with an eye to the three-dimensionality of the head and also arranged in relation to the hair.

Back

The Shape of the Tail

The broom style

The flaired style

It's also good to exaggerate the size of the tail.

Let the large tail pop out boldly from the hem of the skirt.

The "Cool Girl"

The jacket suggests traditional camouflage, with the patches adding a military vibe. The distinctive, large triangular ears are drawn to identify the character as a fox, and the fluffy tail is left out to give her a slender silhouette.

Color Palette

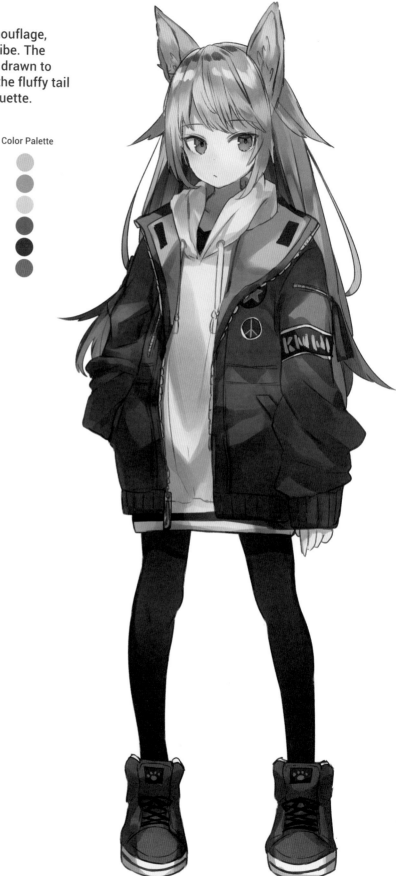

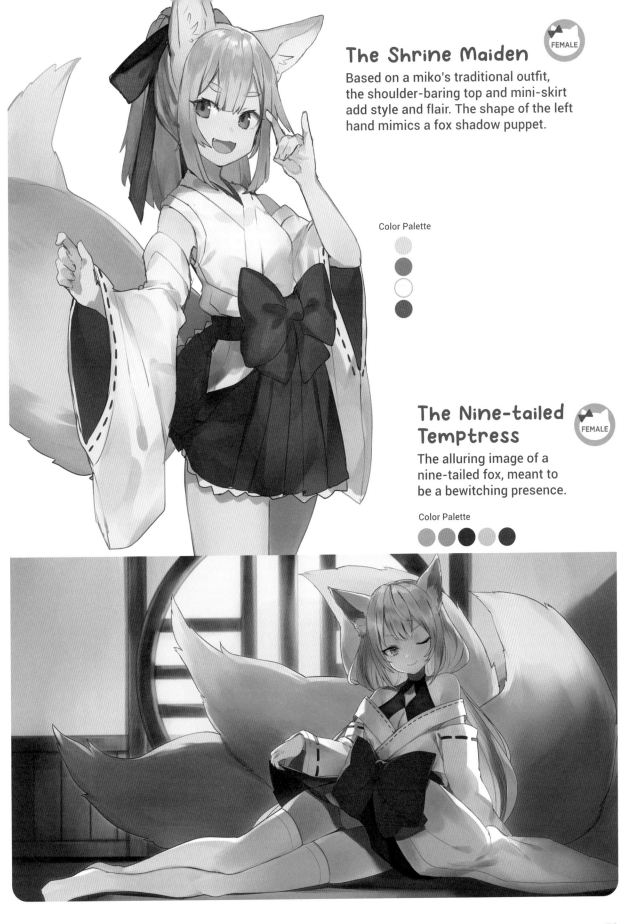

The Shrine Maiden

Based on a miko's traditional outfit, the shoulder-baring top and mini-skirt add style and flair. The shape of the left hand mimics a fox shadow puppet.

Color Palette

The Nine-tailed Temptress

The alluring image of a nine-tailed fox, meant to be a bewitching presence.

Color Palette

The Vacationer

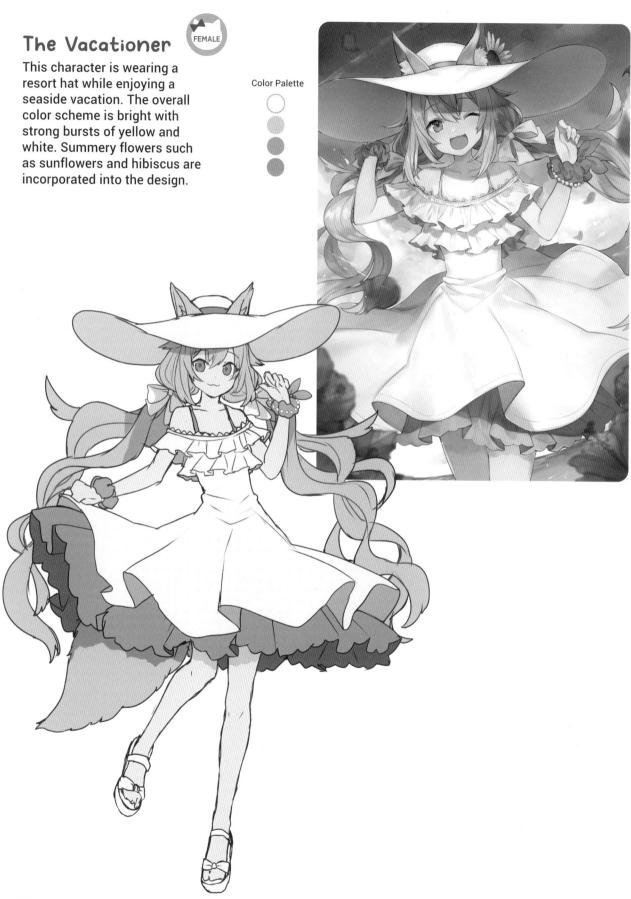

FEMALE

This character is wearing a resort hat while enjoying a seaside vacation. The overall color scheme is bright with strong bursts of yellow and white. Summery flowers such as sunflowers and hibiscus are incorporated into the design.

Color Palette

Fox Ear Designs

Foxes can be found around the world in a range of sizes and varieties. Here we'll take a look at some of the different types and consider designs that take advantage of their characteristics.

The blue color of both the eyes and shorts complements the yellow. It makes the palette more vivid.

Red Fox

A young woman with a mischievous and cheeky expression, her tail is large and her ears are fluffy.

The bushy tail has a white tip.

The inner curl of the big triangular ears are black.

Red nail polish is an accent color.

Color Palette

A splash of red on the shoes too.

The red fox has black legs so make the sneakers black.

 What kind of fox is this?

When people refer to foxes, they're usually referring to the red fox. This animal inhabits a wide range of habitats, including plains, forests and highlands. As its name suggests, its fur is reddish brown or tan, and the backs of its ears and limbs are black. They have a keen sense of smell and hearing, and are excellent hunters, using their ability to jump and leap to catch prey.

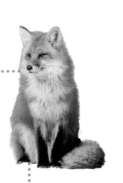

The hood is designed to fit the ears.

Silver Fox

This demure design strongly emphasizes the dark fur of the silver fox. As with the red fox cub, the fluffiness of the ear hairs is exaggerated. To avoid making the whole figure exclusively black and white, blue-purple eyes and red ribbons are added for visual variety.

The ears are the same as those of the red fox: triangular, large and with white inner ear hairs.

Don't overlook the flaired tips of the ears, a kemonomimi hallmark.

Color Palette

The color of the eyes is blue-purple to suggest the silver fox. It also serves to balance the overall palette.

Red ribbons to accentuate her black hair.

What kind of fox is this?

Some red foxes are called silver foxes if they have silvery-hued black-and-white body fur. There is also a type of fox with black fur on its face, back and tail and a crucifix pattern on its back called the cross fox.

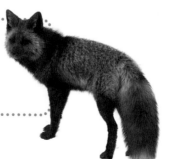

Black hair was chosen to represent the dark fur of the silver fox. The long, flowing wavy lines of the hair convey a relaxed impression, while accentuating the character's modesty.

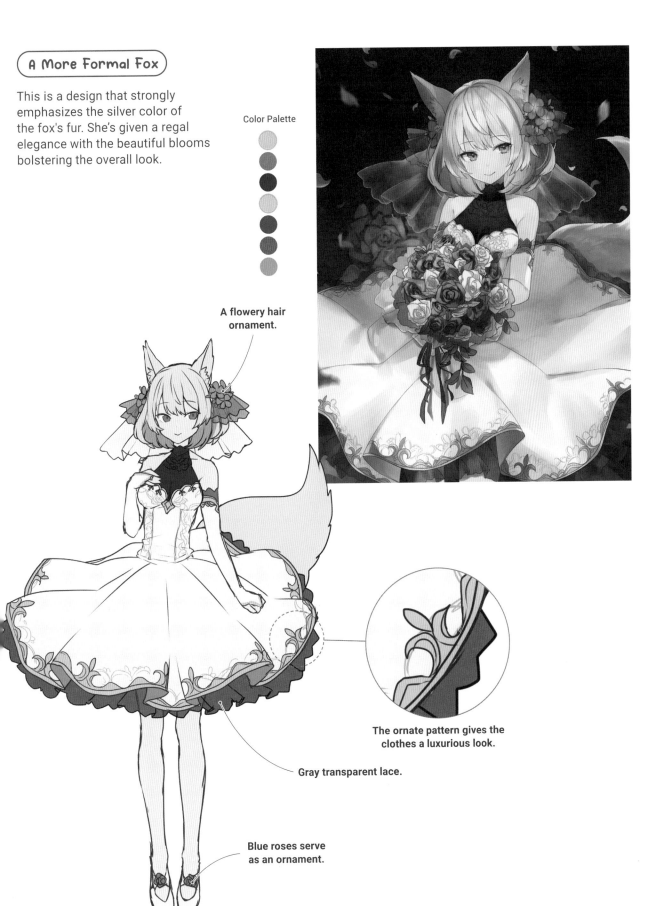

A More Formal Fox

This is a design that strongly emphasizes the silver color of the fox's fur. She's given a regal elegance with the beautiful blooms bolstering the overall look.

Color Palette

A flowery hair ornament.

The ornate pattern gives the clothes a luxurious look.

Gray transparent lace.

Blue roses serve as an ornament.

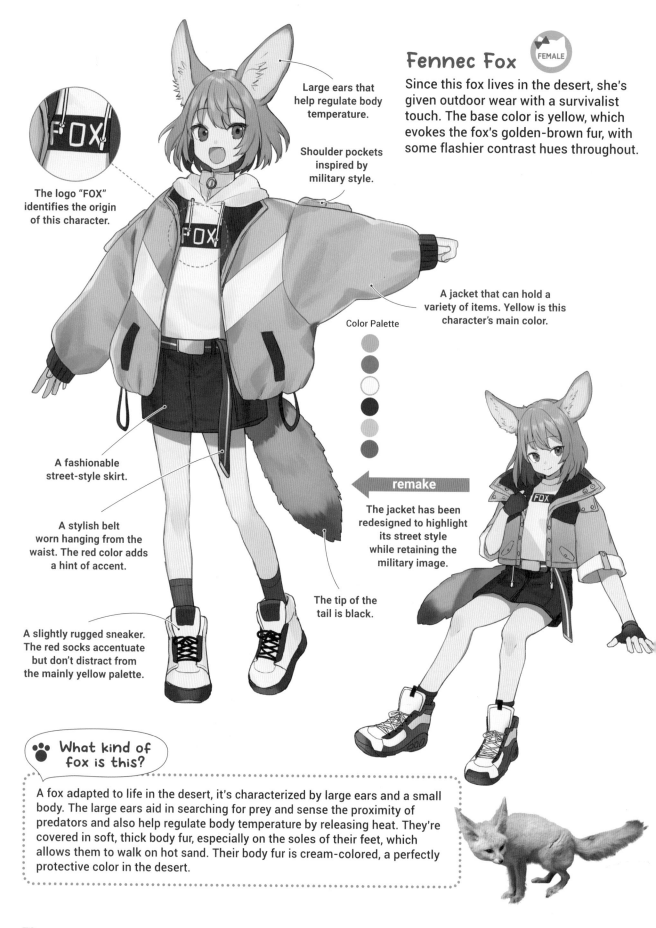

The logo "FOX" identifies the origin of this character.

Large ears that help regulate body temperature.

Shoulder pockets inspired by military style.

Fennec Fox

FEMALE

Since this fox lives in the desert, she's given outdoor wear with a survivalist touch. The base color is yellow, which evokes the fox's golden-brown fur, with some flashier contrast hues throughout.

A jacket that can hold a variety of items. Yellow is this character's main color.

Color Palette

A fashionable street-style skirt.

remake

The jacket has been redesigned to highlight its street style while retaining the military image.

A stylish belt worn hanging from the waist. The red color adds a hint of accent.

A slightly rugged sneaker. The red socks accentuate but don't distract from the mainly yellow palette.

The tip of the tail is black.

What kind of fox is this?

A fox adapted to life in the desert, it's characterized by large ears and a small body. The large ears aid in searching for prey and sense the proximity of predators and also help regulate body temperature by releasing heat. They're covered in soft, thick body fur, especially on the soles of their feet, which allows them to walk on hot sand. Their body fur is cream-colored, a perfectly protective color in the desert.

Arctic Fox

The character is designed wearing fluffy warm-looking garments. The coat is inspired by winter fur, and what's worn underneath is inspired by its summer fur. The key point in the design is the disjunction created between the two simultaneous seasonal looks.

The ears are smaller than those of other foxes.

Color Palette

What kind of fox is this?

This fox is adapted to the extreme cold of the Arctic Circle. Its thick body coat and abundant body fat give it a rounded shape. Its hair is pure white in winter, but turns grayish brown in summer. Some have body hair that is near blue.

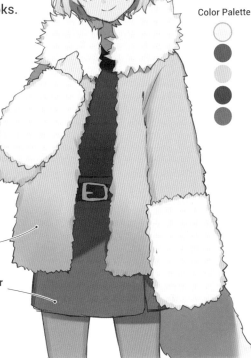

Faux fur in pink and the expected white.

The skirt is inspired by summer hair in a dull brown color.

Color Palette

A sharp-sighted character with a twinkle in his eye.

The Corsac Fox

Another cold-climate denizen, this character's fur-lined collar highlights his silvery tresses. The yellow lining is a subtle color that softens the dark tones of the large coat.

The pattern on the T-shirt is inspired by the white fluffy hair on the chest of the corsac fox.

What kind of fox is this?

This fox's body fur, which is a light brown with red to yellow tints mixed with white, appears to be shimmering and silvery and often suggests a light dusting of snow.

Fox Facial Expressions

The fox's large, triangular ears can be fully utilized to create facial expressions. Take advantage of its typically inscrutable persona when constructing fox-faced characters.

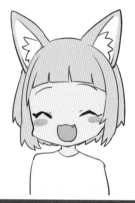

Happy

This basic expression is similar to that of a dog, but with twinkling eyes. The mouth is wide open, but more subdued than a dog's to show the difference.

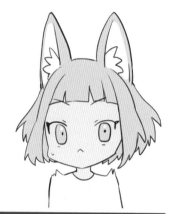

Surprised

Like other animals, its eyes are wide open, and its hair is flared. The large ears are erect, creating a sharp, strong silhouette.

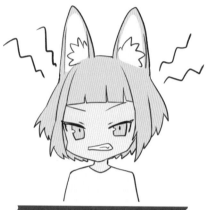

Angry

The big ears are rigid, and the eyes are sharply focused.

Sad

The large ears are lowered, and the eyebrows are C-shaped.

Teasing

The eyes are glazed over, and the mouth is open in a triangular shape.

Squinting

The shape of the eyes is similar to that of an actual fox. Its features make it easy for the viewer to understand what kind of animal it's based on and how it's been anthropomorphized.

Logos & Emblems

Logos on T-shirts and other garments are a fun element to incorporate into designs. Whether you're paying homage to an existing logo or coming up with an entirely new one, an effective design can add character and personality, in addition to helping identify what kind of furry or kemonomimi you're creating.

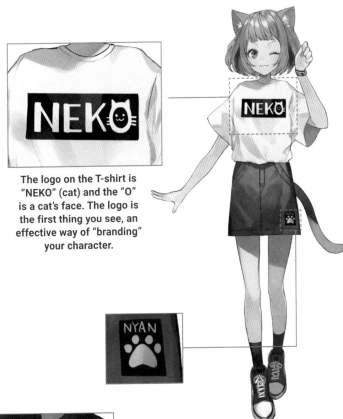

The logo on the T-shirt is "NEKO" (cat) and the "O" is a cat's face. The logo is the first thing you see, an effective way of "branding" your character.

The paw symbol is an effective way of linking your character to its origin animal.

This character is based on a fox, as her T-shirt makes clear.

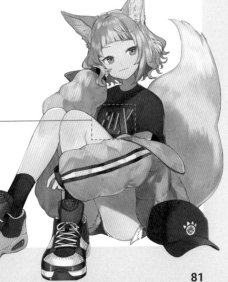

④ Wolves

The wolf is the largest member of the canine family. Although wolves bear certain similarities to the family pet, they have a wider face and larger, more muscular bodies. The key is to accentuate the differences.

Characters with Wolf Ears

Wild, powerful and a little scary: that's the image many people have of wolves. If you emphasize these aspects, it will add depth and resonance to your characterization.

The ears should be rounded at the tips to make them more wolf-like.

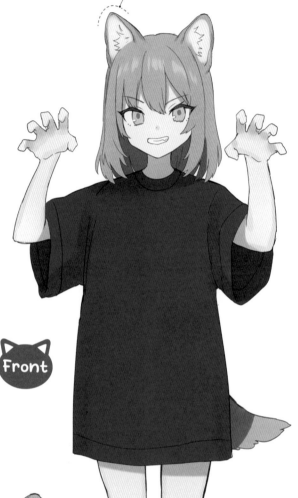

Front

The Shape of the Mouth

The mouth should be drawn slightly larger than a dog's.

The double teeth, which resemble sharp fangs.

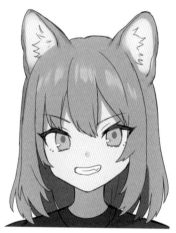

The expression of the eyes and the mouth should suggest the strength and wildness characteristic of wolves.

The ears are thicker than those of cats, and the ear hairs are fluffy like a fox's.

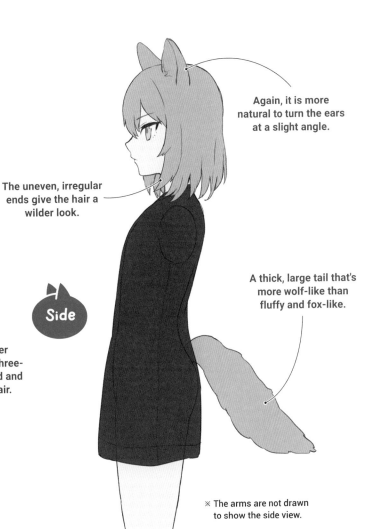

Again, it is more natural to turn the ears at a slight angle.

The uneven, irregular ends give the hair a wilder look.

A thick, large tail that's more wolf-like than fluffy and fox-like.

Side

※ The arms are not drawn to show the side view.

As with the ears of other animals, be aware of the three-dimensionality of the head and its relationship to the hair.

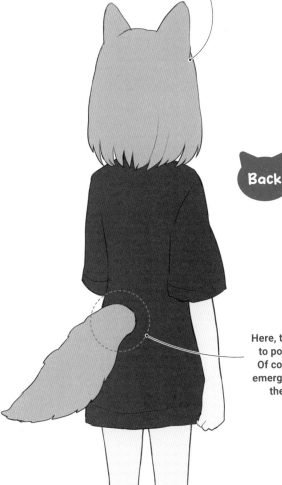

Back

Here, the design allows the tail to pop out from the clothes. Of course, you can also let it emerge from under the hem of the character's clothes.

The Non-threatening Wolf

 FEMALE

She opens her mouth wide and looks cutesy rather than ferocious or threatening. The polished nails and playful expression serve to deepen the impression.

Color Palette

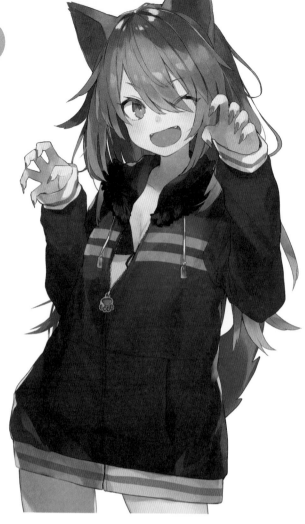

Color Palette

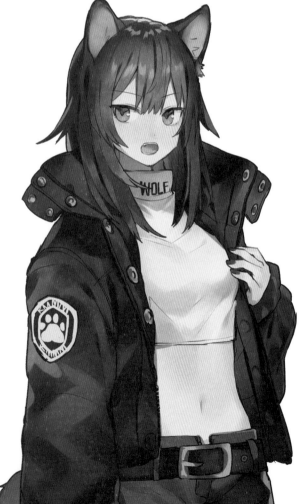

The Wild Wolf

 FEMALE

This is a wolf-eared character wearing a down jacket. The bare navel and short-shorts give the character a wild and free look. The word "WOLF" is placed on the collar to make it easy to identify the source of inspiration.

Wolf Ear Designs

Here we'll look at designs based on the world's wolves and how they've captured our imaginations and influenced legend and folklore.

The cap's red color creates contrast.

Color Palette

Gray Wolf FEMALE

Here, the character is a strong, independent young woman. The design is created with a sense of slick street style.

Wavy, voluminous pigtails give the hair a sense of flow.

The sweatshirt is half tucked into the shorts to create a unique look.

The tail is fluffy.

The zigzag fringe on the shorts fits this wild and free character.

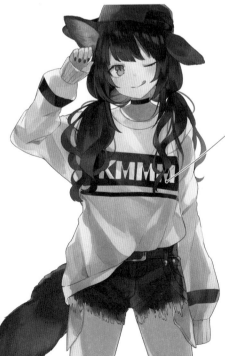

A KMMM (kemonomimi) logo on her T-shirt.

🐾 What kind of wolf is this?

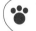

Generally, the term wolf refers to the gray wolf or the timber wolf. They have small ears and long, tapering hairs on their necks. Despite the solitary image of the "lone wolf," they typically live in packs and use their howls are a means of communication.

Arctic Wolf

Inuit dress and fashion influenced this character who brings a modern mood to her cold-climate clothing. The fluffy tail is reinterpreted as the fringe on the hood and skirt.

The shape of the hood fits the ear snugly.

Color Palette

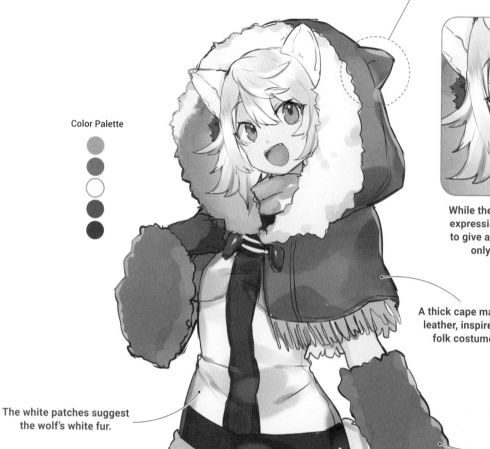

While the character has a gentle expression, the hair is designed to give a sense of wildness that only a wolf possesses.

A thick cape made of leather, inspired by folk costumes.

The character wears fluffy arm sleeves to keep her warm.

The white patches suggest the wolf's white fur.

The tail is white and fluffy.

What kind of wolf is this?

This slightly smaller subspecies of the gray wolf has body fur that's long and bushy in order to protect it from the extremely cold climates it inhabits.

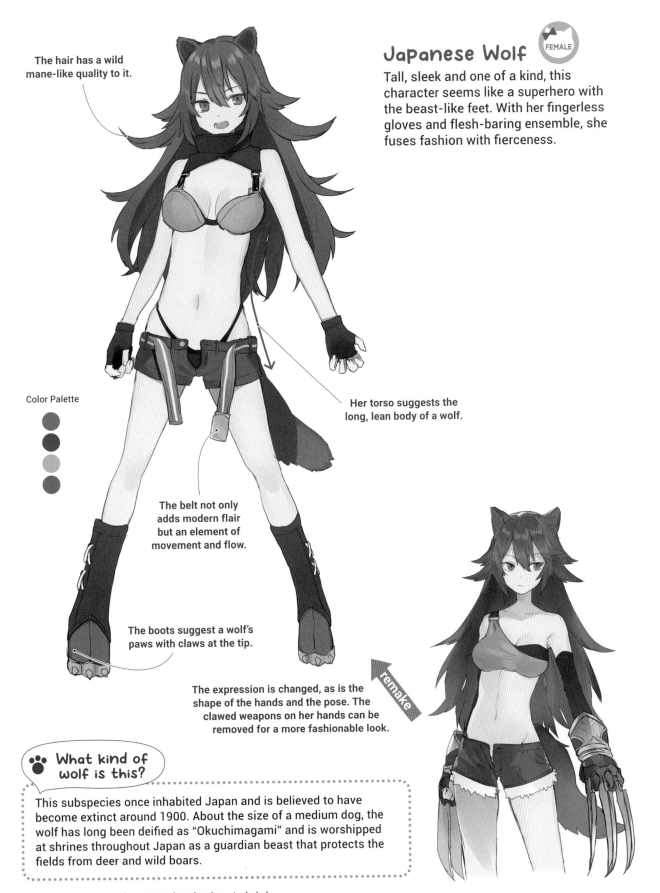

The hair has a wild mane-like quality to it.

Japanese Wolf FEMALE

Tall, sleek and one of a kind, this character seems like a superhero with the beast-like feet. With her fingerless gloves and flesh-baring ensemble, she fuses fashion with fierceness.

Color Palette

Her torso suggests the long, lean body of a wolf.

The belt not only adds modern flair but an element of movement and flow.

The boots suggest a wolf's paws with claws at the tip.

The expression is changed, as is the shape of the hands and the pose. The clawed weapons on her hands can be removed for a more fashionable look.

remake

🐾 **What kind of wolf is this?**

This subspecies once inhabited Japan and is believed to have become extinct around 1900. About the size of a medium dog, the wolf has long been deified as "Okuchimagami" and is worshipped at shrines throughout Japan as a guardian beast that protects the fields from deer and wild boars.

※ The species is now extinct, so no photo has been included.

Wolf Facial Expressions

The term "lone wolf" allows for individual expressions to evolve but for a pack animal, communication is key, so a strong snarl or snaggle-toothed smile make a memorable impression.

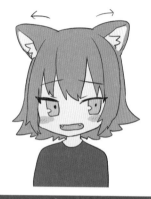

Happy

She seems shy, unable to express her joy fully. The ears are restless, the mouth is half-open and the eyes are wide and smiling.

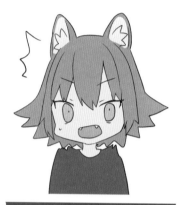

Surprised

The ears are up and the hair flips outward, exaggerating the sharp silhouette.

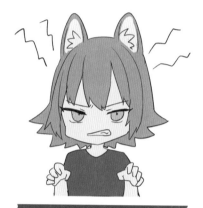

Angry

An angry appearance scarier than a dog's. The eyes are sharp, the brow is wrinkled, and the character is snarling. The ears are pointed at the object of anger.

Sad

The ears are perked up, and the eyes are averted.

Confident

The expression is confident and dignified. The eyes are closed in an inverted U shape, with the eyebrows raised and the mouth set in a wry smile.

Howling

For wolves, howling is a means of communication with their packs. It can be expressed in a variety of ways depending on the expression on its face.

A Gallery of Eyes

The part of the character that most effectively draws in the viewer is the eyes. They're also effective in suggesting or constructing a character's personality, as well as showing the individual style of the artist.

The Shapes of Eyes

The outer corner of the eye is neither too high nor too low.

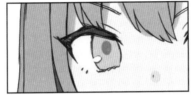

Raising the corner of the eyes gives a strong or sharp impression.

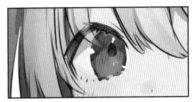

Lowering the outer corner of the eye creates a gentle drooping effect.

The Pupils

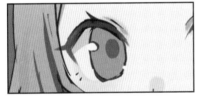

Rounded pupils give a standard impression. They can be used for any character.

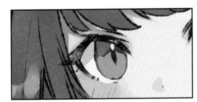

Straight, long slim pupils give the impression of cats and foxes.

The horizontal pupils of hoofed animals such as sheep and cattle.

Slimmer pupils suggest reptiles.

Separating the upper and lower lashes makes the pupils larger, as well as giving an impression of youth and brightness.

In contrast, narrowing the upper and lower lashes makes the pupils smaller, giving an impression of calmness and maturity.

The Eyebrows

Raising the ends of the eyebrows projects an impression of determination and confidence.

Lowering the ends of the eyebrows creates a gentle or befuddled impression.

Especially thick or round eyebrows give a strong sense of presence.

⑤ Rabbits

Rabbits are characterized by their distinctive ears and round, small bodies. The character can be considered from various angles, emphasizing its meekness and timidity or its energetic side as it bounds about.

Make room for the long ears.

Extend the roundness of the body through the hairstyle. The silhouette also gives a soft impression.

Characters with Rabbit Ears

Rabbits are small and docile. Its long ears, white fur and red eyes are its defining furry features.

The Shape of the Mouth

Show the pronounced, rounded upper teeth.

Front

The Shape of the Ears

The Netherland dwarf

The lop-eared

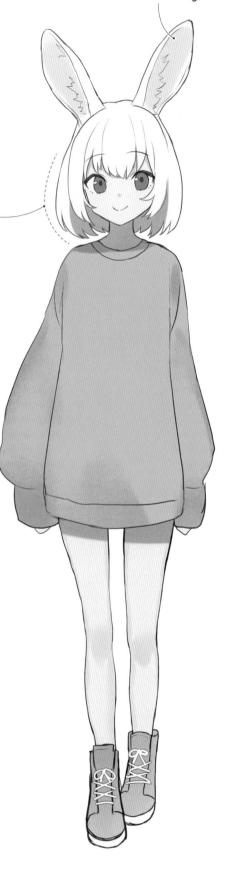

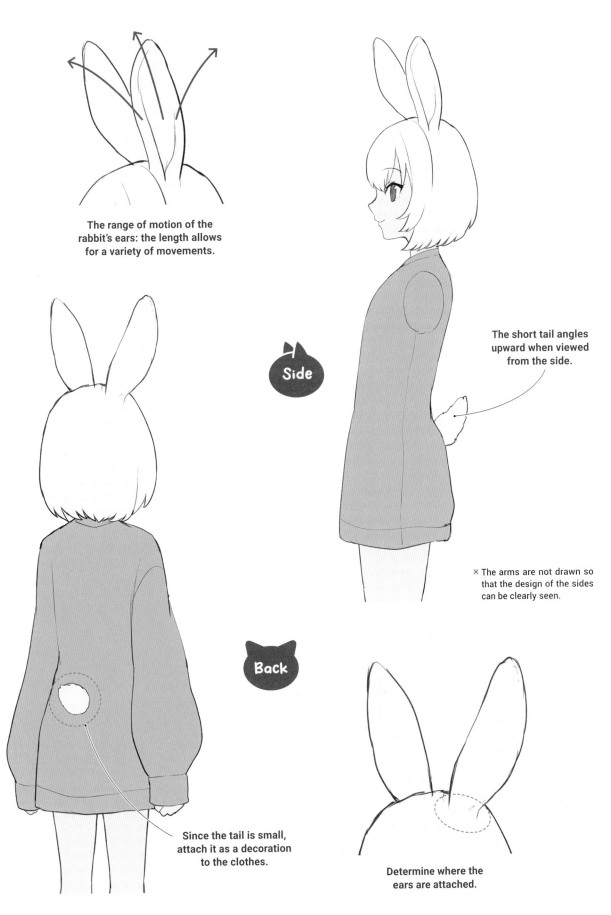

The range of motion of the rabbit's ears: the length allows for a variety of movements.

Side

The short tail angles upward when viewed from the side.

※ The arms are not drawn so that the design of the sides can be clearly seen.

Back

Since the tail is small, attach it as a decoration to the clothes.

Determine where the ears are attached.

The Lolita Style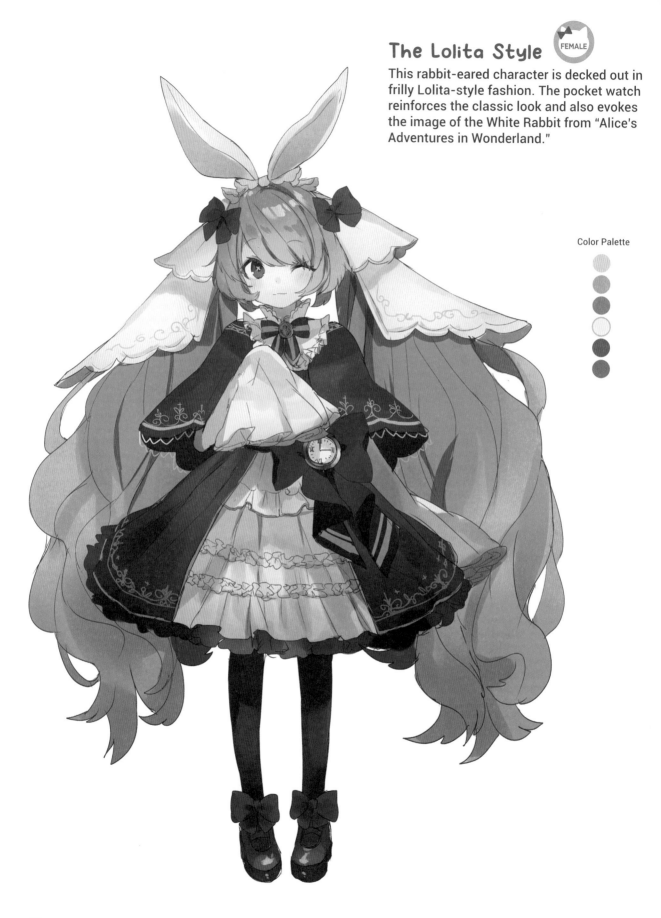

FEMALE

This rabbit-eared character is decked out in frilly Lolita-style fashion. The pocket watch reinforces the classic look and also evokes the image of the White Rabbit from "Alice's Adventures in Wonderland."

Color Palette

The Snow Rabbit 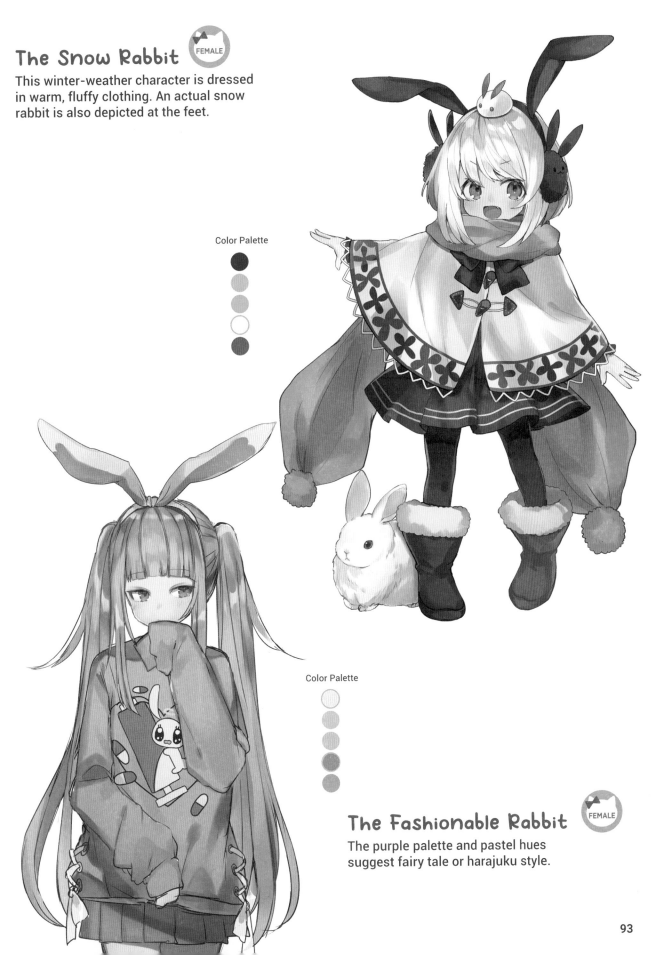 FEMALE

This winter-weather character is dressed in warm, fluffy clothing. An actual snow rabbit is also depicted at the feet.

Color Palette

Color Palette

The Fashionable Rabbit FEMALE

The purple palette and pastel hues suggest fairy tale or harajuku style.

Rabbit Ear Designs

There's no getting around those ears, which extend the line of the body and draw the viewer's attention upward. Balancing the illustration and design become a new challenge when developing these hare-y characters.

The red eyes pop, while the overall color palette is subdued.

The Himalayan

Here a calm and mature older sister is conjured. Although the image is that of an adult, the body shape is more juvenile and the pose slightly childlike.

Striking two-toned ears.

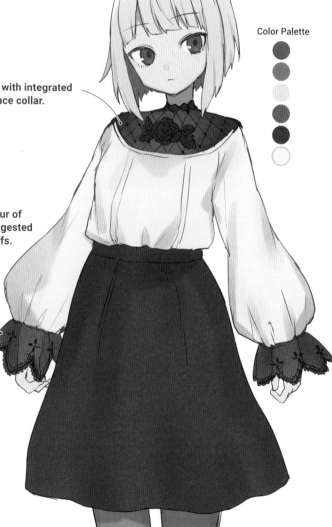

Color Palette

Blouse with integrated lace collar.

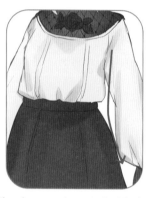

The character has a cylindrical, elongated body shape. The body shape is childlike.

The dusky fur of the feet is suggested by the cuffs.

What kind of rabbit is this?

This breed is characterized by its cylindrical, elongated body shape, erect ears and red eyes. Its fur is short and smooth, with patches of black or brown around the ears, nose, limbs and tail. The rest of the fur is pure white.

The Netherland Dwarf

FEMALE

This poncho-clad character has a playful side, so a slightly sassy, headstrong expression suits her best, along with a wry smile.

Color Palette

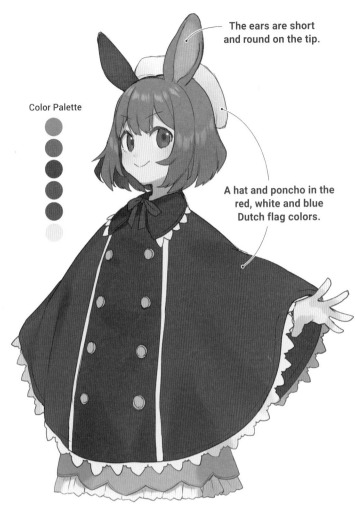

The ears are short and round on the tip.

A hat and poncho in the red, white and blue Dutch flag colors.

What kind of rabbit is this?

As the name implies, this rabbit is characterized by its small body. They have small standing ears and a wide variety of coat colors.

Long bangs are pinned back to show off his expression.

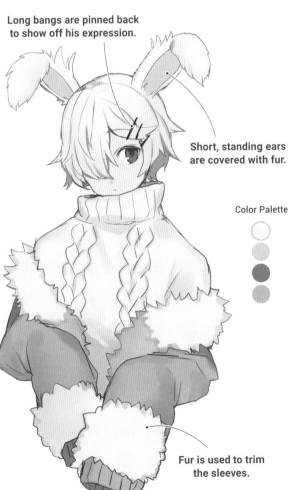

Short, standing ears are covered with fur.

Color Palette

Fur is used to trim the sleeves.

The English Angora

MALE

Since this rabbit has bushy fur, we gave the character bangs so long that his face is obscured. A sweater plus a furry jacket capture the plushness of this breed.

What kind of rabbit is this?

This breed is characterized by its long, bushy fur including hair around its face that is so long that it covers its eyes. Its ears are also covered with patches of fur and have tassels at the tips.

The Japanese White

FEMALE

The white costume of the shrine maiden inspired this ensemble. Red is added to the white base, while blue is included as a highlight.

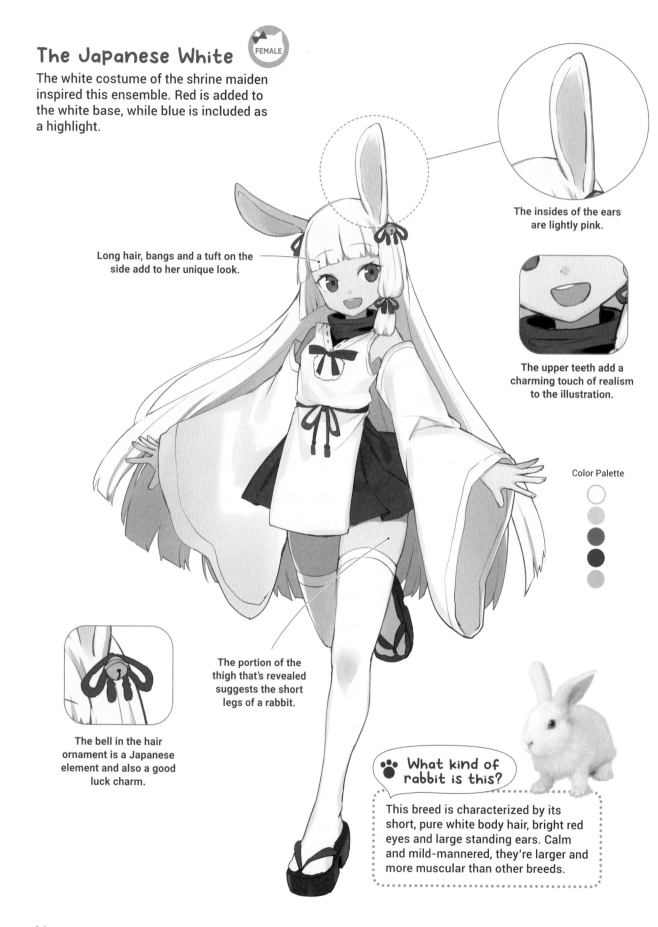

The insides of the ears are lightly pink.

The upper teeth add a charming touch of realism to the illustration.

Long hair, bangs and a tuft on the side add to her unique look.

Color Palette

The portion of the thigh that's revealed suggests the short legs of a rabbit.

The bell in the hair ornament is a Japanese element and also a good luck charm.

What kind of rabbit is this?

This breed is characterized by its short, pure white body hair, bright red eyes and large standing ears. Calm and mild-mannered, they're larger and more muscular than other breeds.

The Lop-eared

Her long hair mimics and suggests the lop-eared look of this breed of rabbit. The plush, full body is replicated by an oversized knit sweater with overly long sleeves.

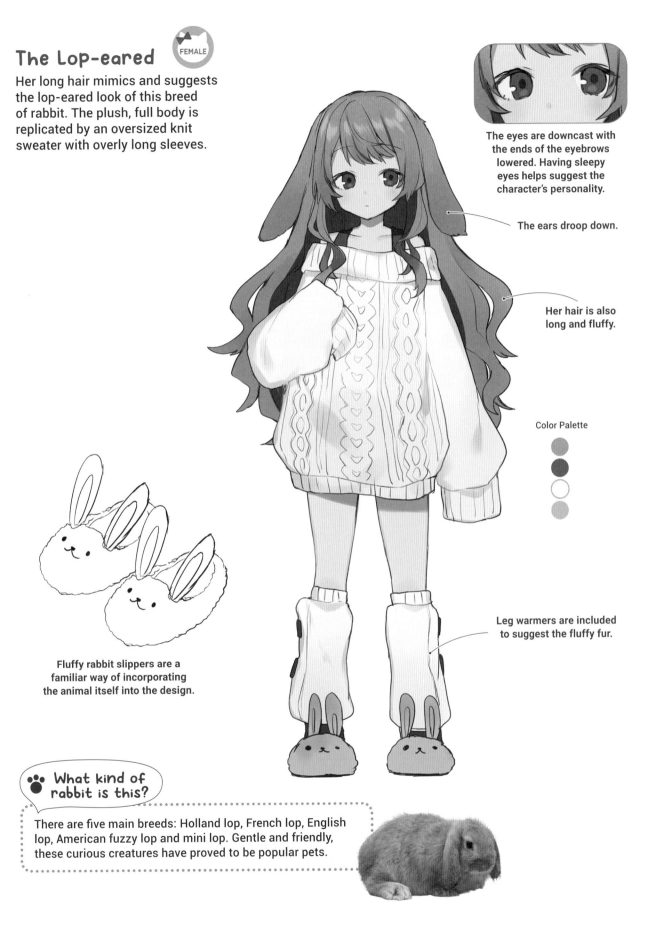

The eyes are downcast with the ends of the eyebrows lowered. Having sleepy eyes helps suggest the character's personality.

The ears droop down.

Her hair is also long and fluffy.

Color Palette

Leg warmers are included to suggest the fluffy fur.

Fluffy rabbit slippers are a familiar way of incorporating the animal itself into the design.

What kind of rabbit is this?

There are five main breeds: Holland lop, French lop, English lop, American fuzzy lop and mini lop. Gentle and friendly, these curious creatures have proved to be popular pets.

The Lionhead

MALE

The rabbit's fuzzy mane encircles the character's hood. A down jacket and warm boots finish off the design, which is all about luxurious layers of softness.

Color Palette

Lionhead's ears look like they are buried in fluffy fur.

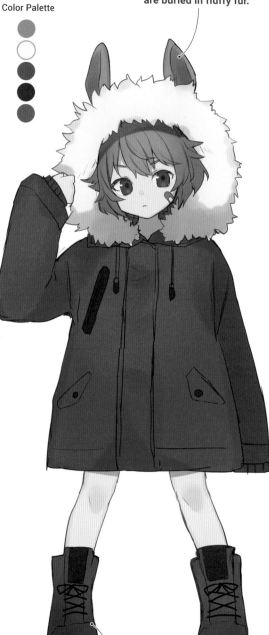

A bandage on his face offers a hint of the wild side.

The characteristic hair is expressed by the fur on the hood.

The insides of the boots are lined with fluffy fur.

🐾 What kind of rabbit is this?

A relatively new rabbit breed from Belgium. As its name suggests, it has long fur that resembles a lion's mane around its face. The most common type of lionhead rabbit is the single mane, which has fur around its face only. The double mane has hair around its face and on the sides of the belly. The coat color varies from black to brown. They're small in stature and have short ears that stand up.

Rabbit Facial Expressions

You can express various emotions by making use of a rabbit's large ears and eyes. The elongated face offers interesting angular options when conjuring emotions and creating moods and moments.

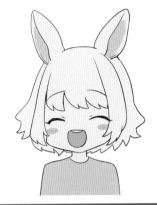

Happy

They open their mouths wider than dogs and smile showing their upper teeth.

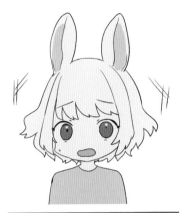

Surprised

An expression that is surprised and scared at the same time, frozen in place. The ears are up, the eyebrows are drawn in the shape of a C and the mouth is distorted.

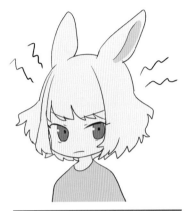

Angry

An ear flipped back, the jaw steely and the mouth set firm, this character is mildly peeved.

Sad

As with other animals, the eyebrows and eyes are in the shape of a C. The ears fall forward.

Embarrassed

Emotions unique to the kemomimi characters that are not found in animals. The left and right ears move differently to express the complex emotions of joy and embarrassment. The eyebrows are in the shape of a C, and the mouth is half-open.

Relaxed

A state of complete relief. Ears fall back completely. The face is relaxed and mellow.

⑥ Ungulates

Hoofed herbivores such as sheep and horses are collectively called ungulates. Here, we'll look at the shapes and characteristics of these various herbivorous animals.

Sheep-eared Characters

Sheep are known for their calm and gentle natures, as they graze the meadows cloaked in their shaggy wool.

Most sheep have ears that flop out to the sides.

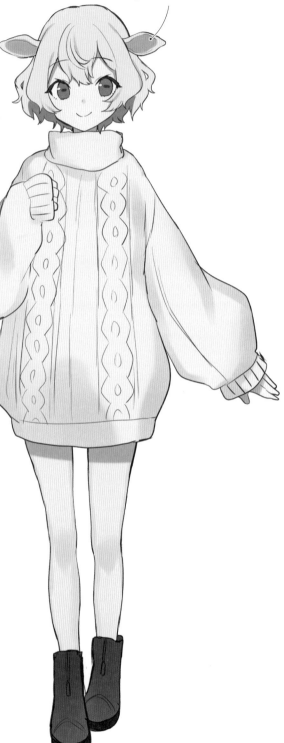

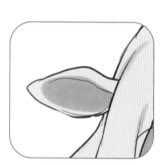

The ears resemble a rabbit's.

Front

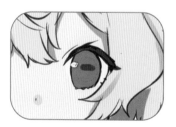

The pupils of ungulates become horizontal when constricted. It can be interesting to incorporate it into the design.

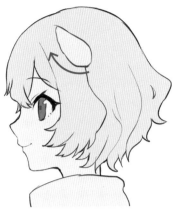

Side

Ears viewed from the side. The ears are easier to convey if they are drawn slightly lifted.

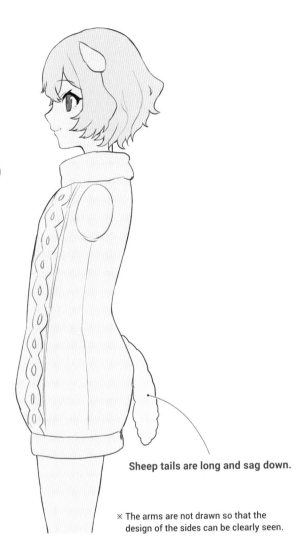

Sheep tails are long and sag down.

※ The arms are not drawn so that the design of the sides can be clearly seen.

Decide the position of the ears and draw them like the rabbit's ears.

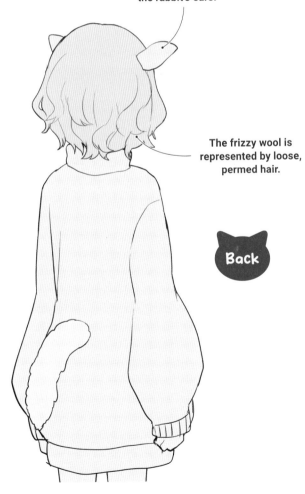

The frizzy wool is represented by loose, permed hair.

Back

HELPFUL TIP ●

Some ungulates have horns. Many have ears just below the horns.

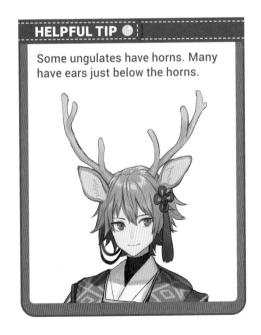

Different Types of Ungulates

Sheep and deer, boars, horses, cows, donkeys and goats. With this group, it's hard to choose which one to transform. Here we'll go through the design and details of each type of ungulate.

Sheep

A shepherd boy with bells and pumpkin-shaped shorts. The fluffy fleece parka and hat help capture his, well, sheepishness.

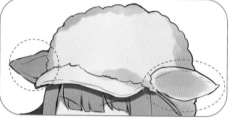

The key to the hat design is the ears.

The bell and red ribbon on the chest are design accents.

Thick flowing locks of hair with sheep ears attached.

Color Palette

A clean Y-line silhouette (see page 23) is used.

Pumpkin-shaped shorts add a unique silhouette.

The design of the loafers is based on sheep hooves.

 What kind of animal is this?

Bovines with frizzy fluffy coats, they're herd animals. There are many breeds of hornless sheep, such as the white-faced Corridale and the Saffolk, which has a black face and body.

Sheep 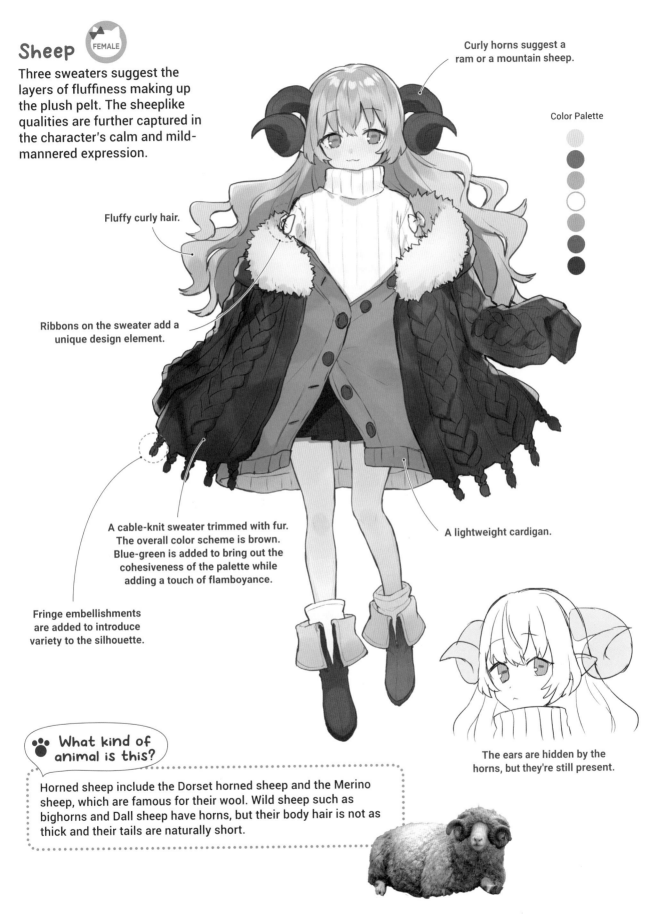 FEMALE

Three sweaters suggest the layers of fluffiness making up the plush pelt. The sheeplike qualities are further captured in the character's calm and mild-mannered expression.

Curly horns suggest a ram or a mountain sheep.

Color Palette

Fluffy curly hair.

Ribbons on the sweater add a unique design element.

A cable-knit sweater trimmed with fur. The overall color scheme is brown. Blue-green is added to bring out the cohesiveness of the palette while adding a touch of flamboyance.

Fringe embellishments are added to introduce variety to the silhouette.

A lightweight cardigan.

The ears are hidden by the horns, but they're still present.

What kind of animal is this?

Horned sheep include the Dorset horned sheep and the Merino sheep, which are famous for their wool. Wild sheep such as bighorns and Dall sheep have horns, but their body hair is not as thick and their tails are naturally short.

Reindeer

FEMALE

A reindeer is often associated with Christmas, thus this character is designed to conjure images of the holiday. Christmas colors, red, white and green, are used.

Since the overall palette leans toward red and brown, the eyes are given blue highlights to create contrast.

The ears are just below the horns.

Distinctive branched horns.

The fur on the hood is inspired by the fluffy hair on the neck.

The duffel coat's exaggerated sleeves create a unique silhouette.

The legs are drawn long and slim to resemble a reindeer's.

Color Palette

Long boots with winter-style fur.

What kind of animal is this?

An animal of the deer family that inhabits cold regions, they're characterized by their large, branch-like horns, which are found on both males and females. These horns are regenerative, with the male's horns falling off in the fall and winter and growing back in the spring, and the female's horns falling off in the spring and summer and growing back in the winter.

Japanese Deer

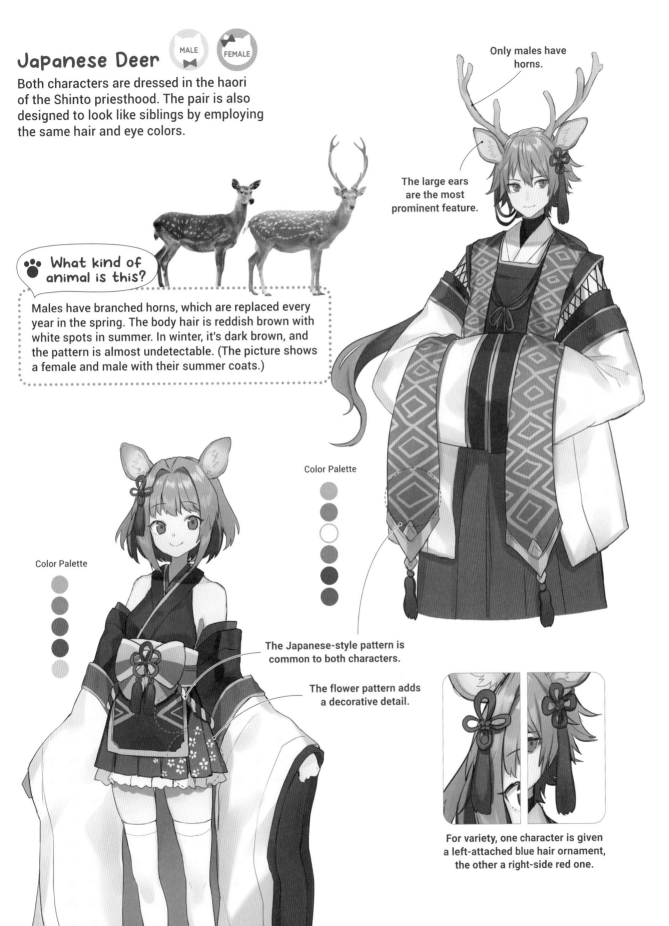

MALE **FEMALE**

Both characters are dressed in the haori of the Shinto priesthood. The pair is also designed to look like siblings by employing the same hair and eye colors.

Only males have horns.

The large ears are the most prominent feature.

🐾 What kind of animal is this?

Males have branched horns, which are replaced every year in the spring. The body hair is reddish brown with white spots in summer. In winter, it's dark brown, and the pattern is almost undetectable. (The picture shows a female and male with their summer coats.)

Color Palette

Color Palette

The Japanese-style pattern is common to both characters.

The flower pattern adds a decorative detail.

For variety, one character is given a left-attached blue hair ornament, the other a right-side red one.

Boar

FEMALE

The image is inspired by the Chinese zodiac sign of the boar and the famous character Cho Hakkai (Zhu Bajie) from the classic Chinese novel "Journey to the West."

The red and gold hues of the dress help establish the Chinese theme.

Slightly wide pointy ears.

The hair is braided, as she represents a messenger of the Chinese zodiac.

A Japanese-style kimono sash and sleeves.

Chinese-style decorations.

Split-toed hoof-shaped clogs.

HELPFUL TIP

The hem of the dress is painted with a peony flower pattern. Peonies are known as the "king of flowers" in China.

Color Palette

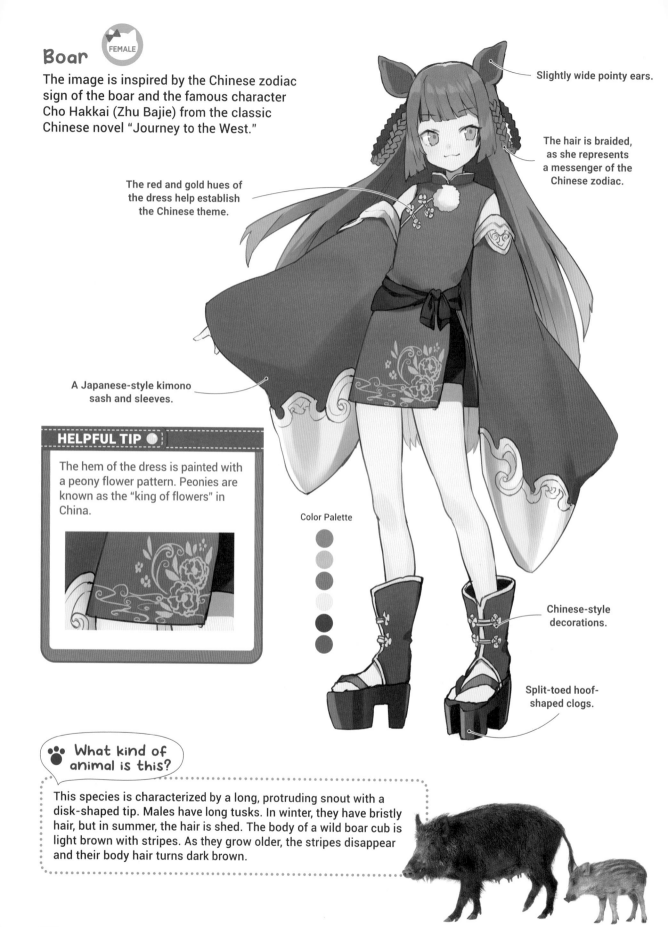

What kind of animal is this?

This species is characterized by a long, protruding snout with a disk-shaped tip. Males have long tusks. In winter, they have bristly hair, but in summer, the hair is shed. The body of a wild boar cub is light brown with stripes. As they grow older, the stripes disappear and their body hair turns dark brown.

Holstein Cow

FEMALE

This gentle and calm older sister type is a postmodern milkmaid, dispensing advice and wisdom in addition to dairy. The horns are optional; leave them off, if you wish.

A cowbell for an old-fashioned touch.

Elongated ears protrude from the sides.

The inner color is inspired by the pattern of a cow.

The horns can be removed, if you wish.

Color Palette

Cow-patterned skirt.

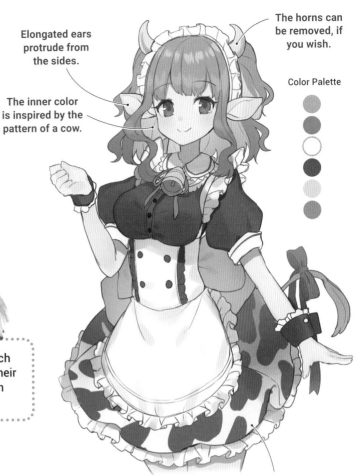

What kind of animal is this?

The most common dairy cow is the Holstein, which originated in the Netherlands. Characterized by their black and white speckled pattern, they're champion milk producers.

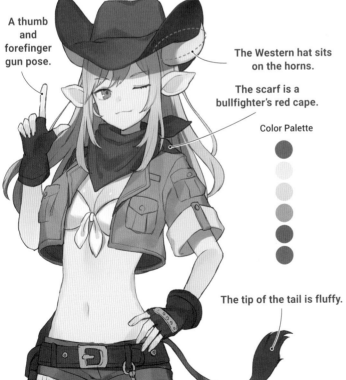

A thumb and forefinger gun pose.

The Western hat sits on the horns.

The scarf is a bullfighter's red cape.

Color Palette

The tip of the tail is fluffy.

Bull

FEMALE

The design is a combination of a bull and a cowgirl. She fuses rugged flair with retro glam.

What kind of animal is this?

More muscular and aggressive than the females of the same species, bulls have long been an important symbol in many religions and cultures.

Horse FEMALE

This flashy fly girl is a racehorse in the flesh. The satiny "Pink Ladies" jacket and sassy cap add to the overall look of this character's original style.

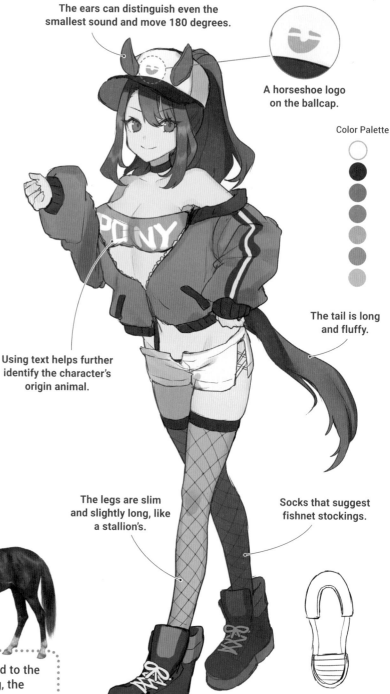

The ears can distinguish even the smallest sound and move 180 degrees.

A horseshoe logo on the ballcap.

Color Palette

Using text helps further identify the character's origin animal.

The tail is long and fluffy.

A loose and tousled ponytail is the perfect if obvious choice.

The legs are slim and slightly long, like a stallion's.

Socks that suggest fishnet stockings.

What kind of animal is this?

When they're relaxed, their ears are turned to the side. When they're focused on something, the ears point in that direction. When alert, the ears extend to the side. And when a horse is angry or provoked, the ears are tilted back.

The soles of the sneakers are hoof-shaped.

HELPFUL TIP

Horses have one hoof on each toe. Sheep, deer, goats and wild boars have two hooves, while cows have four.

Donkey

MALE

The character is designed as an adventurer traveling through a Western wilderness, enduring the harsh conditions. The cape gives the illustration flow and movement.

Color Palette

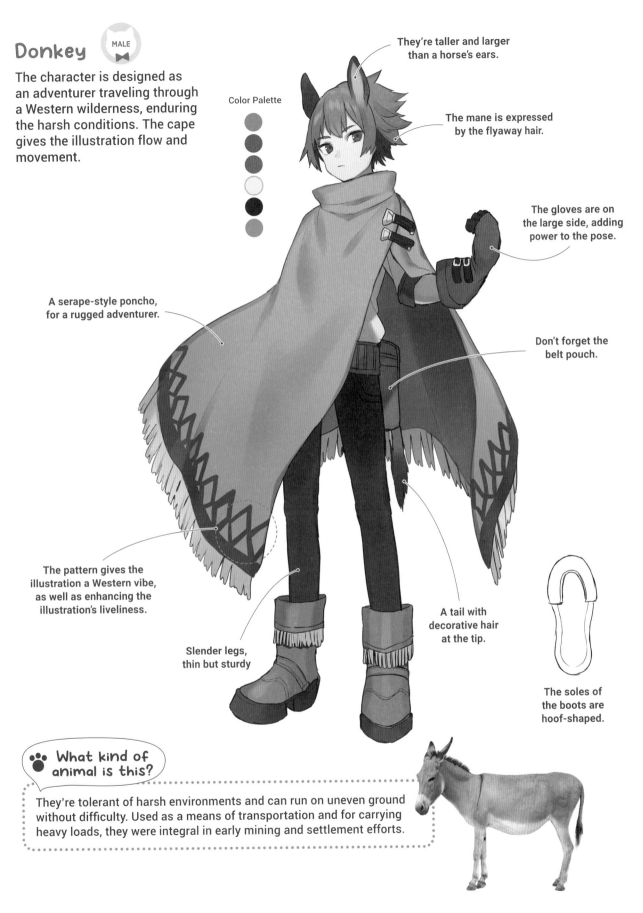

They're taller and larger than a horse's ears.

The mane is expressed by the flyaway hair.

The gloves are on the large side, adding power to the pose.

A serape-style poncho, for a rugged adventurer.

Don't forget the belt pouch.

The pattern gives the illustration a Western vibe, as well as enhancing the illustration's liveliness.

Slender legs, thin but sturdy

A tail with decorative hair at the tip.

The soles of the boots are hoof-shaped.

What kind of animal is this?

They're tolerant of harsh environments and can run on uneven ground without difficulty. Used as a means of transportation and for carrying heavy loads, they were integral in early mining and settlement efforts.

109

Goat

FEMALE

A Black Mass attended by Satanic goat nuns? Why not! While creating opposite characters, they can share the same colors as a common element.

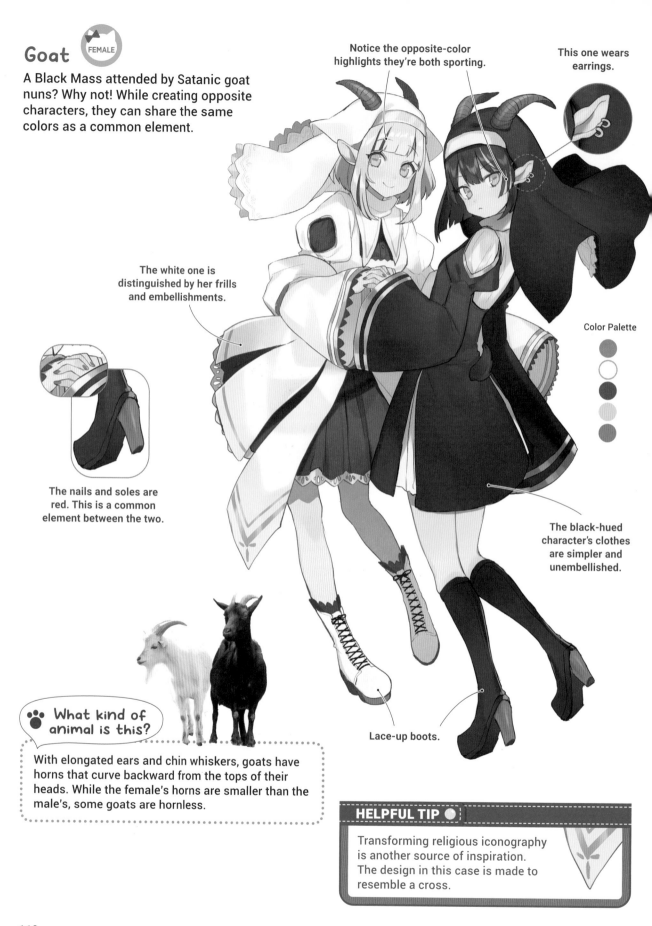

Notice the opposite-color highlights they're both sporting.

This one wears earrings.

The white one is distinguished by her frills and embellishments.

The nails and soles are red. This is a common element between the two.

Color Palette

The black-hued character's clothes are simpler and unembellished.

Lace-up boots.

What kind of animal is this?

With elongated ears and chin whiskers, goats have horns that curve backward from the tops of their heads. While the female's horns are smaller than the male's, some goats are hornless.

HELPFUL TIP

Transforming religious iconography is another source of inspiration. The design in this case is made to resemble a cross.

⑦ Birds

Feathered furries anyone? Here, we'll go through designs inspired by different birds and see what beaks, feathers and talons can be turned into.

Rockhopper Penguin MALE ⋈

This casual young man comes with a beak-shaped face mask. The flamboyant feathers on the bird's head present the perfect opportunity to have fun with hair color.

Color Palette

The crown feathers on the head are represented by an orange streak.

The traditional black and white of the penguin.

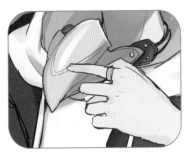

A unique face mask in the shape of a beak.

🐾 What kind of animal is this?

Penguins are birds that specialize in swimming instead of flying. Rockhopper penguins inhabit at the southern part of the Indian Ocean. They're small in size, with a black head and yellow feather crown. Their eyes are red and their beaks are orange. They don't walk, but rather leap as they advance on land, often from rock to rock.

The decorative belt is in a contrast color: orange.

Emperor Penguin

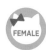
FEMALE

The silhouette with the hood is based on the penguin's shape. Since they're found in cold climates, the character comes with a highly thermal weather-resistant jacket.

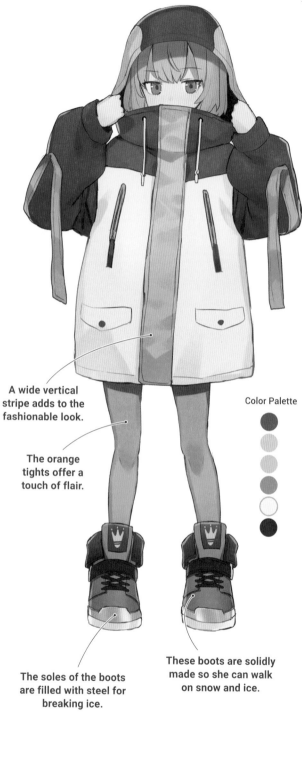

Hood off

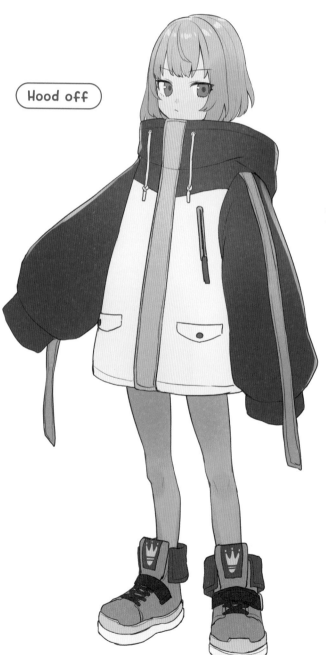

A wide vertical stripe adds to the fashionable look.

The orange tights offer a touch of flair.

Color Palette

The soles of the boots are filled with steel for breaking ice.

These boots are solidly made so she can walk on snow and ice.

Here the colors are those of a penguin chick.

Chick version

Orange is retained as a contrast color.

Color Palette

The logo on the boots is a penguin's footprint. The upper half symbolizes an emperor's crown.

🐾 What kind of animal is this?

The largest penguin in Antarctica, they have a cylindrical body and dense plumage developed for the harsh environment. Their heads, wings and feet are black, with a white belly and yellow or orange cheeks. They also have pink or orange patterns on their black beaks. The chicks have thin feathers and are generally gray with a black head and white face.

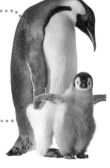

Crow

FEMALE

This witch has a crow fixation. Here, black is used for prominent areas such as the hat and the lining of the cloak. Shadows and the colors adjacent to black are adjusted so that hue doesn't dominate.

Color Palette

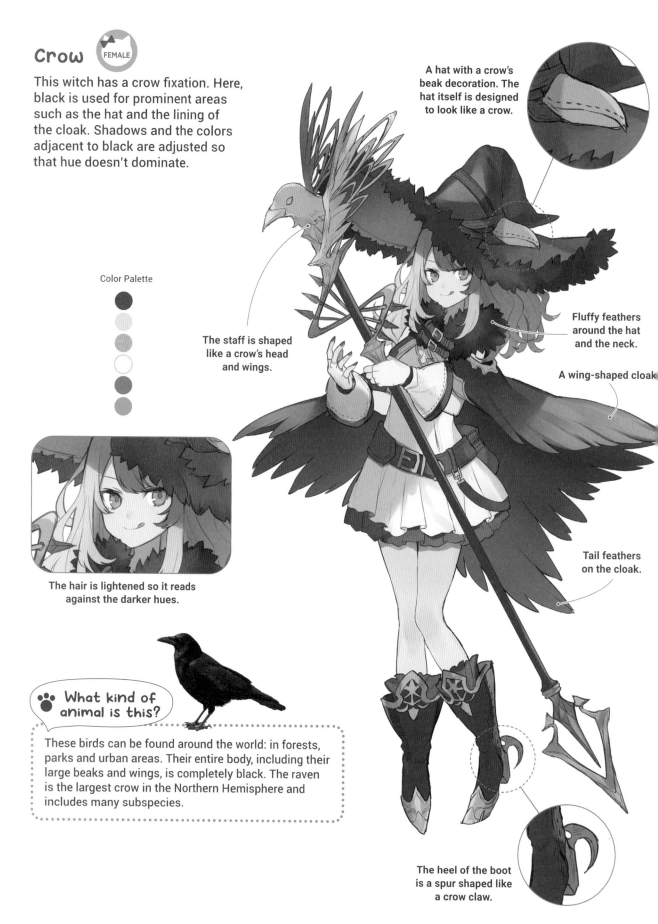

The staff is shaped like a crow's head and wings.

The hair is lightened so it reads against the darker hues.

A hat with a crow's beak decoration. The hat itself is designed to look like a crow.

Fluffy feathers around the hat and the neck.

A wing-shaped cloak

Tail feathers on the cloak.

The heel of the boot is a spur shaped like a crow claw.

What kind of animal is this?

These birds can be found around the world: in forests, parks and urban areas. Their entire body, including their large beaks and wings, is completely black. The raven is the largest crow in the Northern Hemisphere and includes many subspecies.

Swan FEMALE

Tchaikovsky's ballet "Swan Lake" is crisscrossed with the image of a migratory bird from a cold region to create this icily elegant ballerina. Swans are of course mostly white, but blue is included to create a cooler contrast.

Inspired by Russian hats, the feather ear pads add warmth.

Feather form winged motifs.

What kind of animal is this?

Characterized by their pure white plumage and graceful body shape, mute swans have orange bills and live near bodies of water.

Color Palette

The classic ruffled tutu.

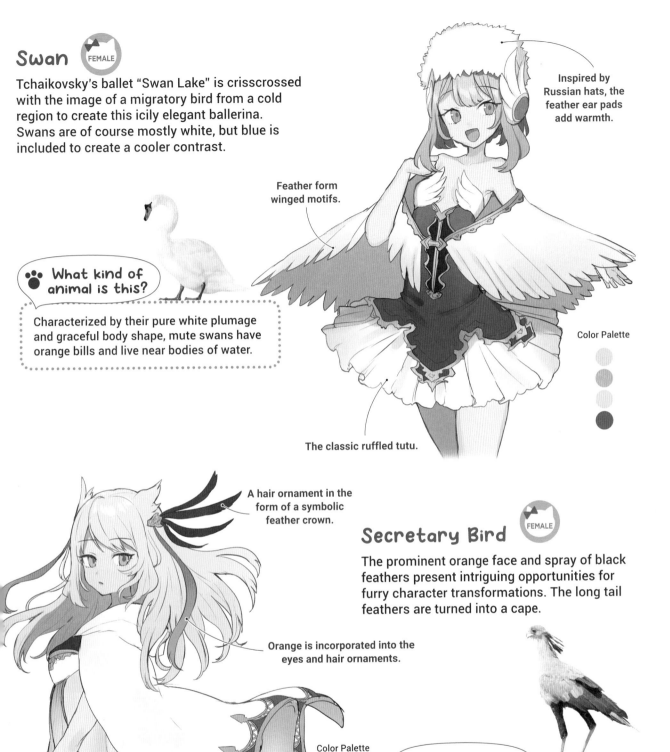

A hair ornament in the form of a symbolic feather crown.

Secretary Bird FEMALE

The prominent orange face and spray of black feathers present intriguing opportunities for furry character transformations. The long tail feathers are turned into a cape.

Orange is incorporated into the eyes and hair ornaments.

Color Palette

What kind of animal is this?

An African bird of prey, they're characterized by their orange face, quill-like crown feathers and long wedge-shaped tails. They're good runners with long legs. By no means flightless, they take to the air when provoked.

The darker tights add solidity to the illustration's lower portion.

8 Other Animals

This is furry world so why limit your imagination to creating commonplace characters? There are so many creatures to choose from, the world's diversity awaits your artist's eye and mind!

Common Degu

A bundle of nerves or a ball of energy, this little sister type is infused with an energetic exuberance. The pastel palette gives her a dreamy fairy tale or harajuku vibe.

Color Palette

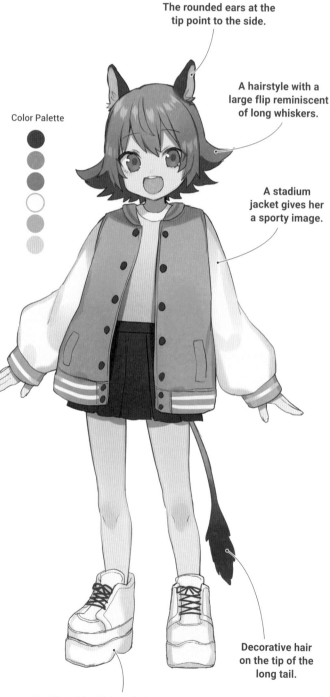

The rounded ears at the tip point to the side.

A hairstyle with a large flip reminiscent of long whiskers.

A stadium jacket gives her a sporty image.

Decorative hair on the tip of the long tail.

Fashionable thick-soled sneakers

Don't forget to show the rodent-like upper teeth.

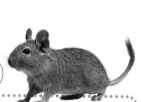

👣 What kind of animal is this?

A member of the rodent family, the degu lives in the Andes but has become popular as a pet in recent years. The fur has become more varied in color, but it typically yellowish brown. The eyes are surrounded by a cream-colored rim.

Mouse

 FEMALE

City mouse or country mouse?
Field mouse or house mouse?
This small creature can inspire
a range of furry personas.

Color Palette

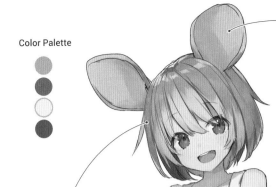

Large round ears.

Big bead-like eyes.

The long thin tail is practically hairless.

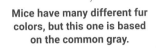

Mice have many different fur colors, but this one is based on the common gray.

The yellow of the hoodie is repeated in the cheese logo below.

Color Palette

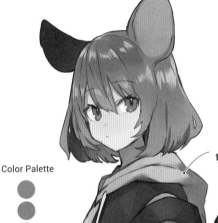

The striped rope-like pattern is a delicate detail that finishes off the character.

The logo is another way the character's rodent roots are explored.

The backpack has cat ears and a tail, creating a whimsical contrast.

 What kind of animal is this?

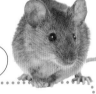

With over 1,000 species of rodents, the vast family of mice has adapted to a wide range of environments. From pest to pet, they've worked their way into human life and have spread throughout the globe.

Hamster

This character is based on Thumbelina from Hans Christian Andersen's fairy tale. The overall design highlights the hamster's rounded silhouette.

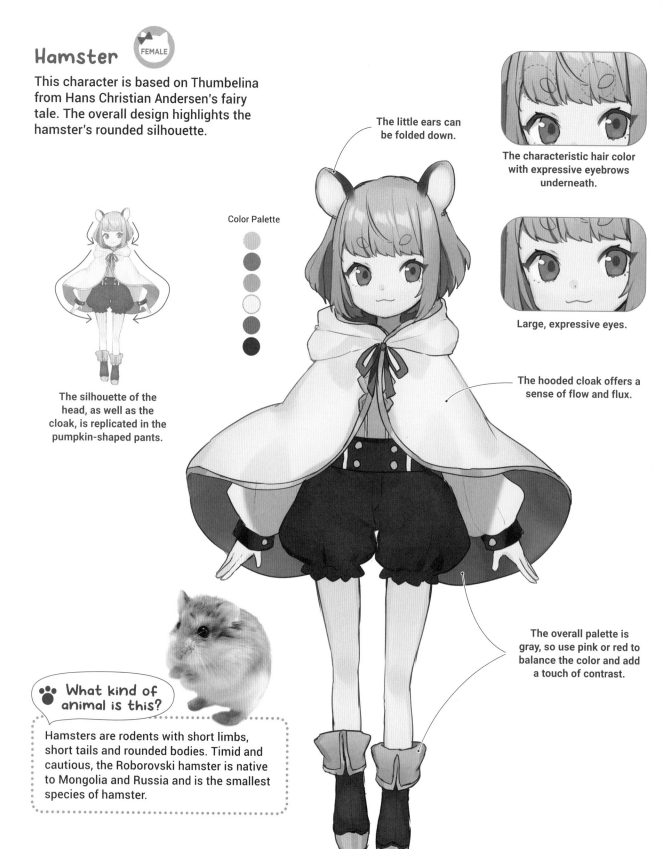

The little ears can be folded down.

The characteristic hair color with expressive eyebrows underneath.

Color Palette

Large, expressive eyes.

The hooded cloak offers a sense of flow and flux.

The silhouette of the head, as well as the cloak, is replicated in the pumpkin-shaped pants.

The overall palette is gray, so use pink or red to balance the color and add a touch of contrast.

What kind of animal is this?

Hamsters are rodents with short limbs, short tails and rounded bodies. Timid and cautious, the Roborovski hamster is native to Mongolia and Russia and is the smallest species of hamster.

Chipmunk FEMALE

For this young artist, eager for experience, the colors are mainly autumnal, the red, yellow and browns of fall foliage.

An iconic beret suggests a painter.

Chipmunk ears don't have tufts.

Autumn plants (ginkgo, acorns and grapes) work as decorations.

Braided pigtails off a classic, juvenile look.

Overalls show her individuality while also looking stylish.

The tail has vertical stripes.

The upper teeth add a rodent-like touch.

Sketch Book

Color Palette

🐾 What kind of animal is this?

This little rodent is characterized by its black-and-white striped pattern and cheek pouches that can be stuffed with food. Good climbers, their bushy tails are used for a variety of purposes, including for balance and for warmth.

Casual sneakers.

119

Weasel

FEMALE

This character is a kunoichi (or female ninja) with a weasel's swiftness. Her attire allows for ease of movement.

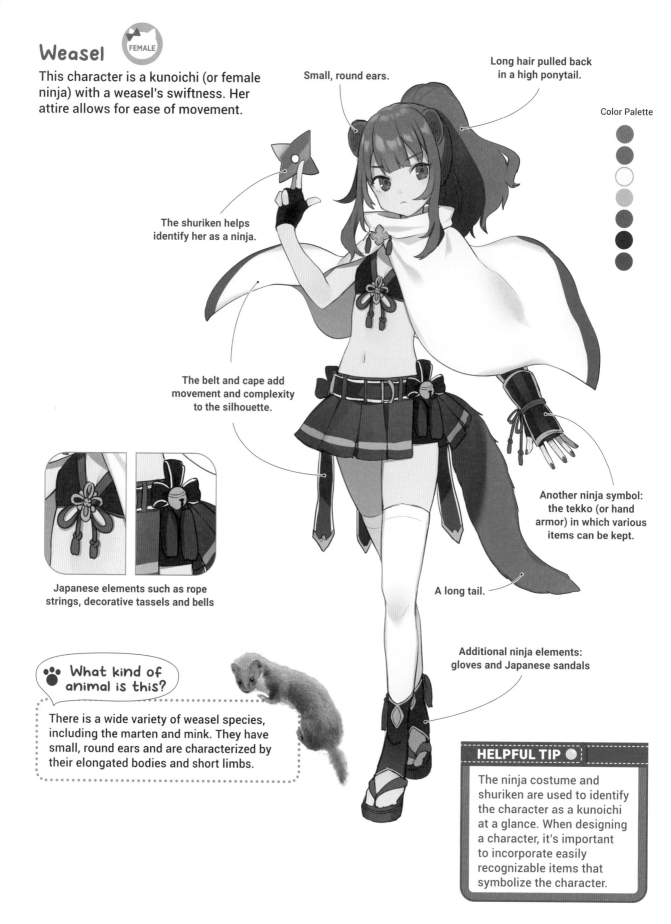

Small, round ears.

Long hair pulled back in a high ponytail.

Color Palette

The shuriken helps identify her as a ninja.

The belt and cape add movement and complexity to the silhouette.

Japanese elements such as rope strings, decorative tassels and bells

Another ninja symbol: the tekko (or hand armor) in which various items can be kept.

A long tail.

Additional ninja elements: gloves and Japanese sandals

What kind of animal is this?

There is a wide variety of weasel species, including the marten and mink. They have small, round ears and are characterized by their elongated bodies and short limbs.

HELPFUL TIP

The ninja costume and shuriken are used to identify the character as a kunoichi at a glance. When designing a character, it's important to incorporate easily recognizable items that symbolize the character.

Ferret FEMALE

This sleek-bodied character wears a hoodie dress that makes her silhouette look even longer. The color scheme is white and brown, which are the common fur colors of ferrets.

The brown pattern around the eyes blends with the dark strips along the face.

Off-the-shoulder makes it fashionable.

Color Palette

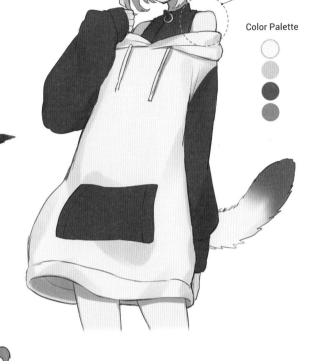

What kind of animal is this?

A member of the weasel family, ferret's coat colors vary, but brown and white are the most common shades. They love to burrow into holes and tight places.

To add movement, the hairstyle includes a side ponytail.

Otter FEMALE

Picture a lively and energetic young woman at a swimming hole, about to jump in. The colors are cheerful and bright to fit her mood.

The tail tapers toward the tip.

Color Palette

What kind of animal is this?

A good swimmer, the otter is characterized by its long, slender body, short limbs, sleek fur and prominent whiskers.

Polar Bear

FEMALE

Another character dressed and ready for the elements. The hooded muffler is made in the image of a polar bear's face and paws.

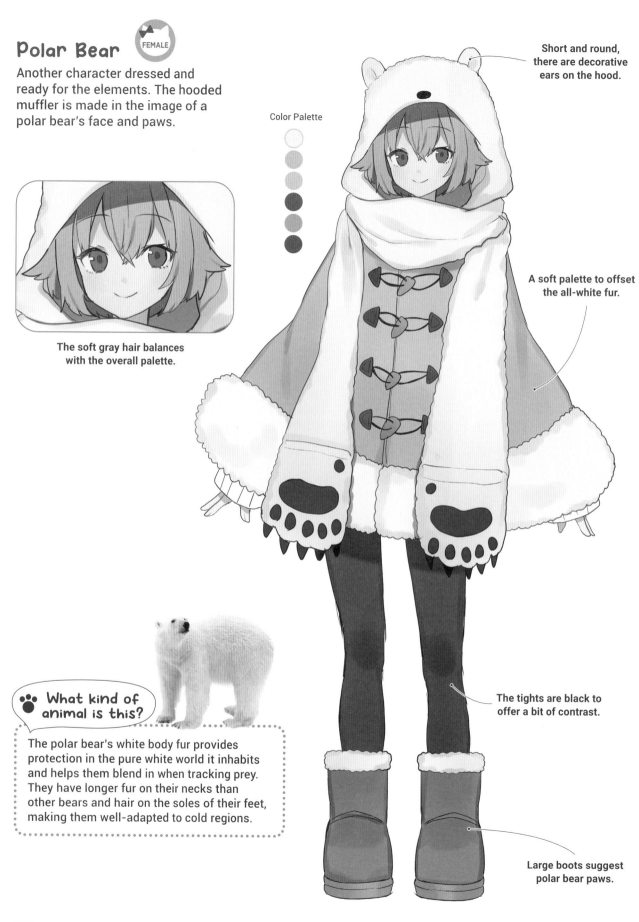

Color Palette

Short and round, there are decorative ears on the hood.

A soft palette to offset the all-white fur.

The soft gray hair balances with the overall palette.

The tights are black to offer a bit of contrast.

What kind of animal is this?

The polar bear's white body fur provides protection in the pure white world it inhabits and helps them blend in when tracking prey. They have longer fur on their necks than other bears and hair on the soles of their feet, making them well-adapted to cold regions.

Large boots suggest polar bear paws.

Giant Panda 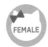 FEMALE

The color scheme is black and white, with red and gold highlights to underscore the Chinese theme throughout.

The bun or chignon on both sides is made to look like a panda's ears.

Black streaks in the hair are used as an accent.

A hair ornament with a panda face. Incorporating the animal itself into the design makes the initial inspiration all the more apparent.

Color Palette

The skirt is ruffled and flouncy.

What kind of animal is this?

The most distinctive feature of the panda is its black and white body fur. Their diet is mostly bamboo, with bamboo shoots in spring, bamboo leaves in summer and bamboo stalks in winter.

Boots that resemble panda paws.

Raccoon FEMALE

Instead of the stereotypical masked thief in the night, this character is a detective who tracks down perpetrators. The slightly cheeky facial expression offers a glimpse of the raccoon's mischievous side.

Since the overall color of the dress is brown, a red ribbon is attached to the top of the hat and to the chest.

A ribbon adds another decorative design detail.

She carries a magnifying glass to easily identify her as a detective.

A detective-like cape reflecting a raccoon's fur color, she's the image of Sherlock Holmes.

The ears have white borders.

The tail is striped.

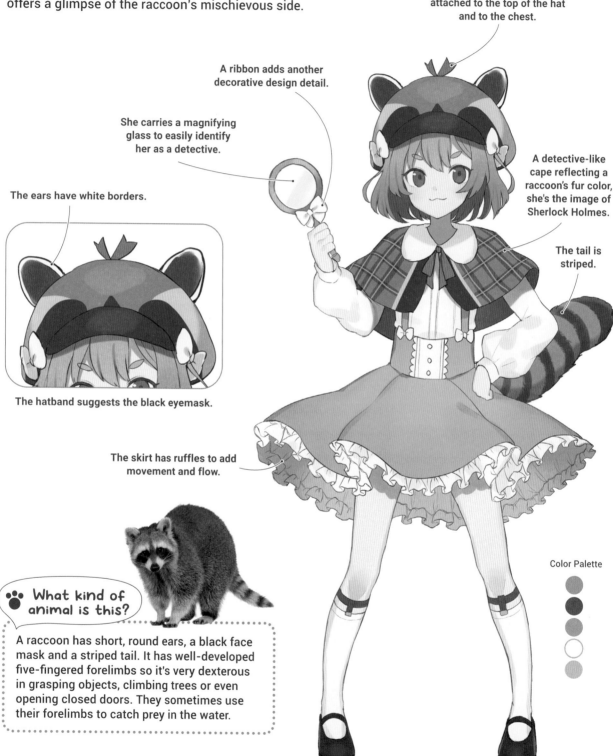

The hatband suggests the black eyemask.

The skirt has ruffles to add movement and flow.

Color Palette

What kind of animal is this?

A raccoon has short, round ears, a black face mask and a striped tail. It has well-developed five-fingered forelimbs so it's very dexterous in grasping objects, climbing trees or even opening closed doors. They sometimes use their forelimbs to catch prey in the water.

Hedgehog FEMALE

This character conjures the round silhouette and prickly volume of a hedgehog. A short, voluminous skirt mirrors the swirling spiky effect of the hair.

🐾 **What kind of animal is this?**

A hedgehog's most distinctive feature, the "needles" on its body, are sclerotized hairs. When they're angry or threatened, they curl up and raise the needles as a potent form of self-protection.

The bouncy hair has a spiky or needle-like look to it.

Slightly pointed ears

Outswept hair

Color Palette

Two layers of frill add visual variety.

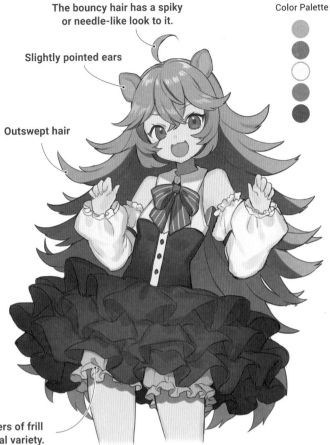

Color Palette

A golden circlet on his head.

A monkey's ears are similar to those of humans but slightly larger.

The burst of blue at the hips acts in contrast to the red.

Rhesus Monkey MALE

The design is based on a character from the classic novel "Journey to the West." Using red and gold as the base colors gives the overall design high Chinese style. The cloud motif adds a fluffy pedestal.

🐾 **What kind of animal is this?**

Living in southern China and northern India, they're adapted to a variety of environments, including mountains, forests and plains. Their body hair is generally reddish, with patches of gray on the upper body and orange on the lower portions.

The Leaping Cloud is another emblem of this character.

The shoes are in the shape of monkey's feet.

Brown Long-eared Bat 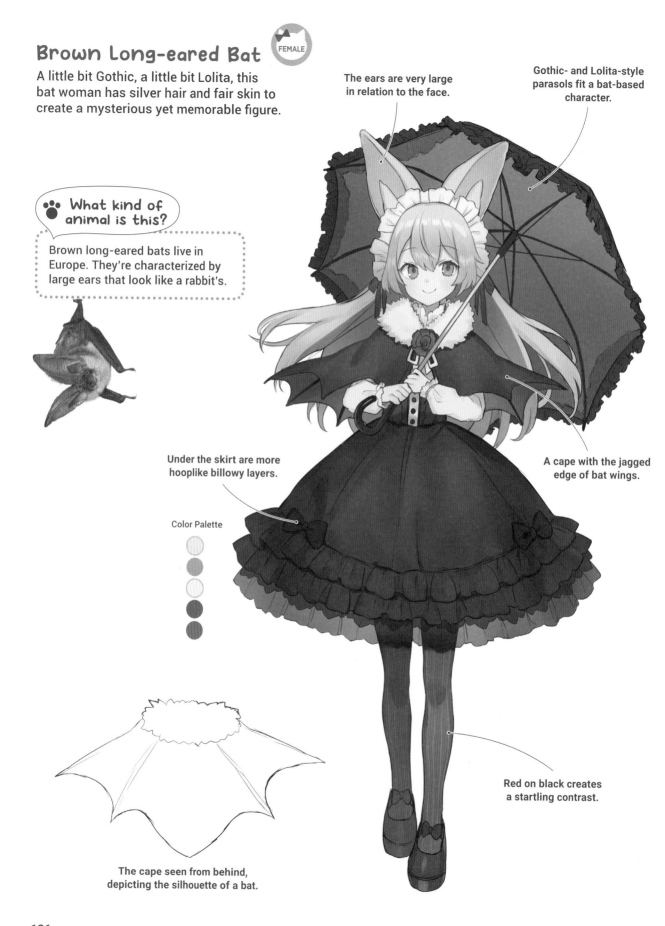 FEMALE

A little bit Gothic, a little bit Lolita, this bat woman has silver hair and fair skin to create a mysterious yet memorable figure.

🐾 What kind of animal is this?

Brown long-eared bats live in Europe. They're characterized by large ears that look like a rabbit's.

The ears are very large in relation to the face.

Gothic- and Lolita-style parasols fit a bat-based character.

Under the skirt are more hooplike billowy layers.

Color Palette

A cape with the jagged edge of bat wings.

Red on black creates a startling contrast.

The cape seen from behind, depicting the silhouette of a bat.

Python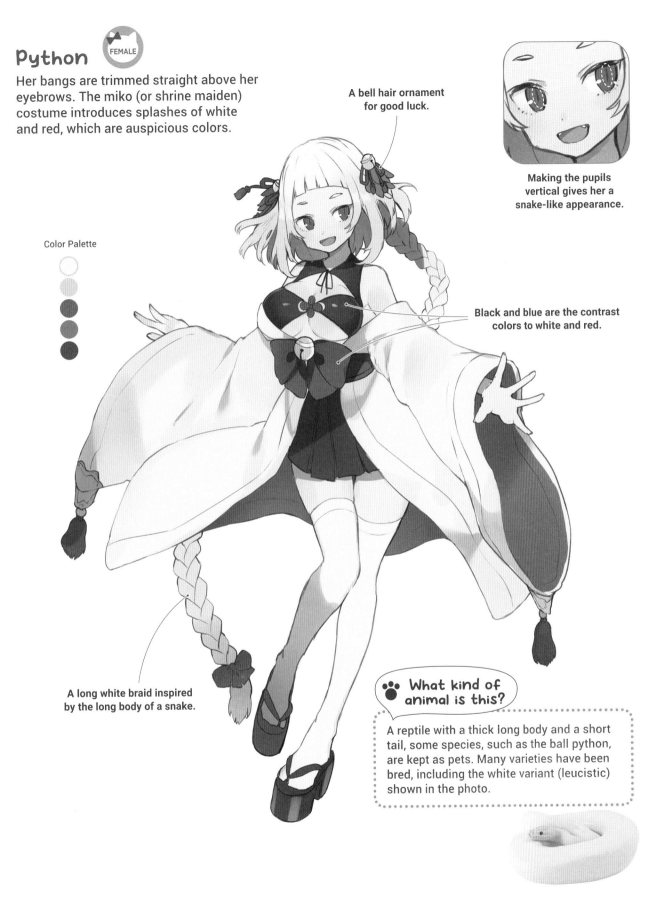

FEMALE

Her bangs are trimmed straight above her eyebrows. The miko (or shrine maiden) costume introduces splashes of white and red, which are auspicious colors.

A bell hair ornament for good luck.

Making the pupils vertical gives her a snake-like appearance.

Color Palette

Black and blue are the contrast colors to white and red.

A long white braid inspired by the long body of a snake.

What kind of animal is this?

A reptile with a thick long body and a short tail, some species, such as the ball python, are kept as pets. Many varieties have been bred, including the white variant (leucistic) shown in the photo.

Furries as Chibi-style Characters

Chibi-style illustrations, which can exaggerate the ears and tails, are a perfect match for kemonomimi or furry characters.

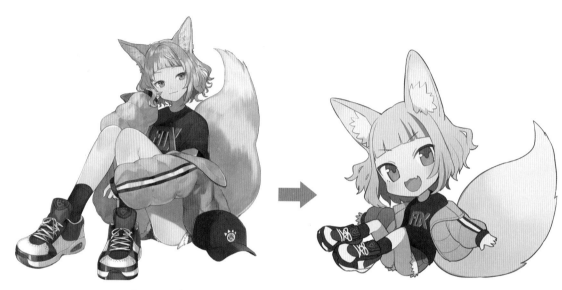

2-head-sized

A simple silhouette. No need for detailed drawing but the trick is to exaggerate only the parts you want to show.

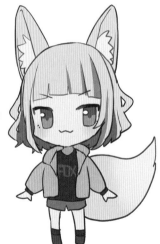

Ears/tail
Key parts such as ears and tails should be exaggerated.

Face
Eyes should be large and centered.

Limbs
Make them small and short.

Clothes
Omit lines and don't draw in fine details. However, to give the face a simple but unique appearance, draw at least the key features

For example: Words on the T-shirt

3-head-sized

The more space you have, the more detail you can add and thus the more refinement and polish.

Ears/tail
Just as with the 2-headed character, exaggerate and draw them larger.

Face
For the 3-headed figure, the eyes and mouth are separated for balance with the body.

Limbs
Unlike the 2-headed model, the individual parts are drawn larger.

Clothes
Follow the details of the original design as closely as possible.

For example:
Fringe and pockets on pants
Lettering on a T-shirt
Details on shoes

Drawing 2-head-sized characters

Let's look briefly at the process for drawing a two-head-sized chibi-style character.
The trick is to draw the face and the body in two separate groups.
The basic drawing method is the same as for a three-head-sized character.

Although the ears will eventually be hidden, it's easier to grasp the image if you draw them.

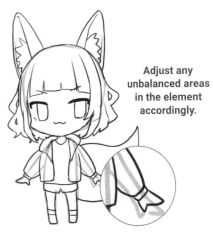

Adjust any unbalanced areas in the element accordingly.

1. Draw two circles the same size. For a three-headed figure, draw three circles.

2. Draw the body. Decide the shape of the head and body according to the size.

3. Draw the lines. Thin out the element and place it on the bottom. Then draw the hair and eyes, and then the clothes.

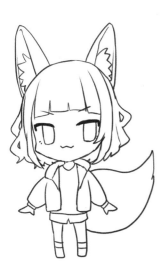

Shadows are simply and solidly painted. Gradation is also seen.

Put on the T-shirt text.

4. Add in lines. By drawing thicker lines, you can make them look more chibi.

5. Apply the colors. Shadows and highlights should be simple to create a clean look.

6. To blend in with the paint, adjust the color of the lines and the process is complete.

⑨ Mythological Creatures

Finally, we will go through designing characters inspired by imaginary being from mythology and folklore. While there are no rules for their appearance, many of them are created by combining elements of creatures that already exist.

Flame Dragon [FEMALE]

Red dominates this character's palette and appropriately so, the flame motif, bat wings and beast-like feet and tail adding to the effect.

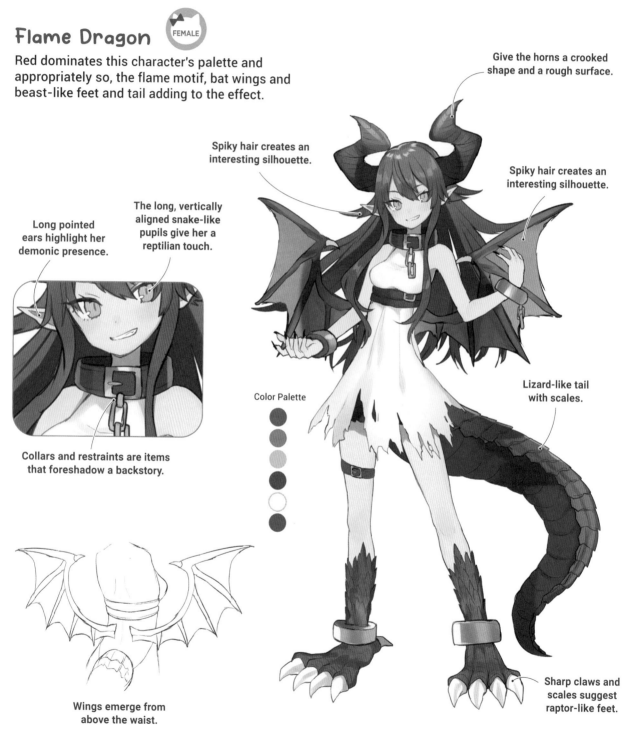

Give the horns a crooked shape and a rough surface.

Spiky hair creates an interesting silhouette.

Spiky hair creates an interesting silhouette.

Long pointed ears highlight her demonic presence.

The long, vertically aligned snake-like pupils give her a reptilian touch.

Collars and restraints are items that foreshadow a backstory.

Color Palette

Lizard-like tail with scales.

Wings emerge from above the waist.

Sharp claws and scales suggest raptor-like feet.

Sea Serpent

FEMALE

Aquatic ornaments bring this slinky creature to life, with lots of exposed skin and an overall silhouette suggesting a fish's fluttering fins.

The supple horns are inspired by the long fins on deep-sea fish.

Another reptilian eye ups the serpentine vibe.

Color Palette

Transparent ruffles suggest ripples of crystal clear water.

The ears suggest a fish's fins.

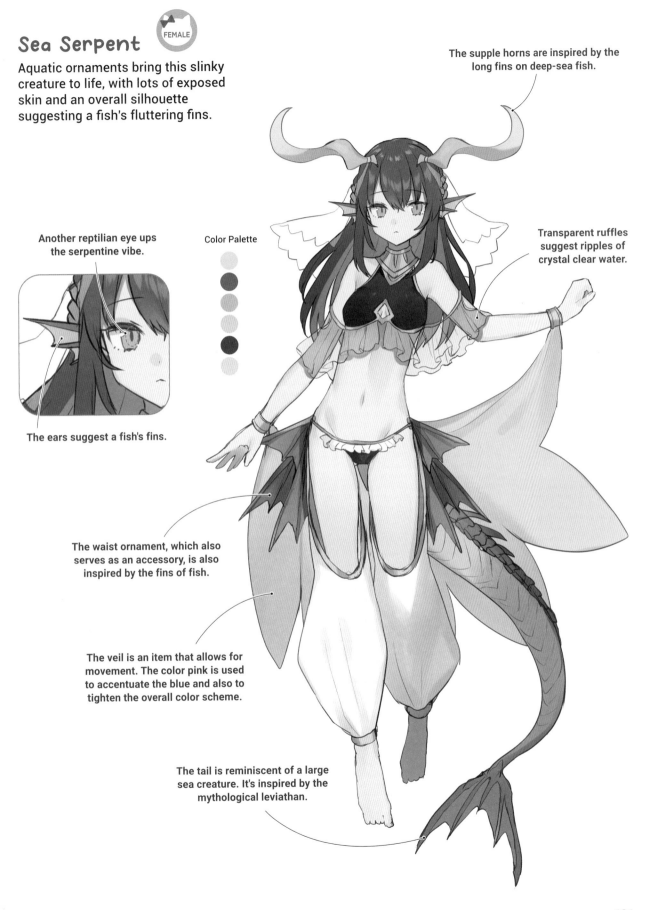

The waist ornament, which also serves as an accessory, is also inspired by the fins of fish.

The veil is an item that allows for movement. The color pink is used to accentuate the blue and also to tighten the overall color scheme.

The tail is reminiscent of a large sea creature. It's inspired by the mythological leviathan.

Wyvern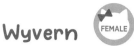

This crazy coat conjures a winged wyvern, borrowing also from the silhouette of a pterodactyl. It gives this somewhat cutesy character a touch of wildness.

Color Palette

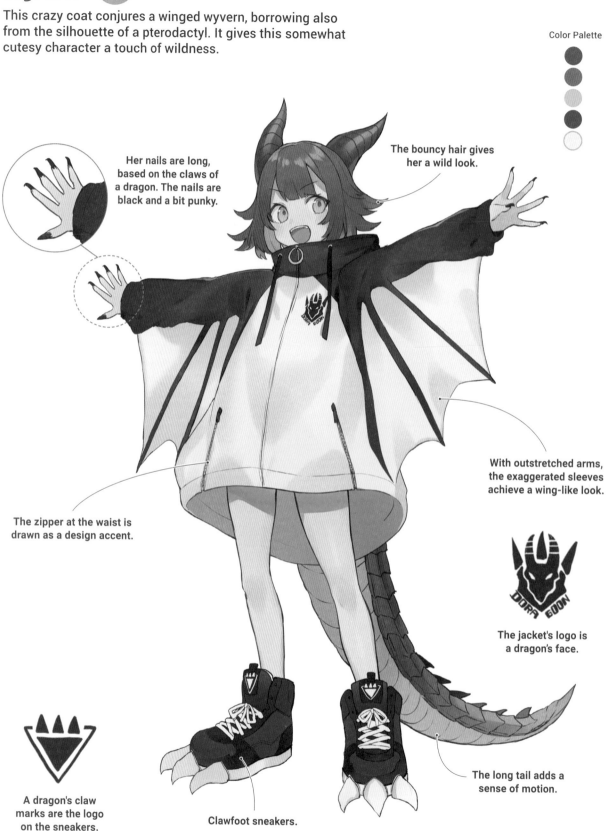

Her nails are long, based on the claws of a dragon. The nails are black and a bit punky.

The bouncy hair gives her a wild look.

With outstretched arms, the exaggerated sleeves achieve a wing-like look.

The zipper at the waist is drawn as a design accent.

The jacket's logo is a dragon's face.

The long tail adds a sense of motion.

A dragon's claw marks are the logo on the sneakers.

Clawfoot sneakers.

Back

Horns grow from the back of the head.

Draw a hole in the coat and the tail can be drawn out.

Hood On

When the hood is on, it fits completely up to the horns.

The hem of the hoodie is designed to be longer in the back.

What are dragons?

Legends of dragons exist as myths and folklore in all parts of the world, both ancient and modern. They have sharp fangs and claws, bat-like wings, lizard-like scales and limbs and a variety of reptilian body shapes.

Angel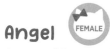

A pure white angel translates perfectly into a heavenly nurse, here to cure all your spiritual ailments.

The nurse's cap is a substitute for the angel's halo. The feather ornament is added to make it easier to recognize that she is an angel.

Color Palette

This sweet nurse is unfortunately about to give a shot, an implement that makes her profession instantly recognizable.

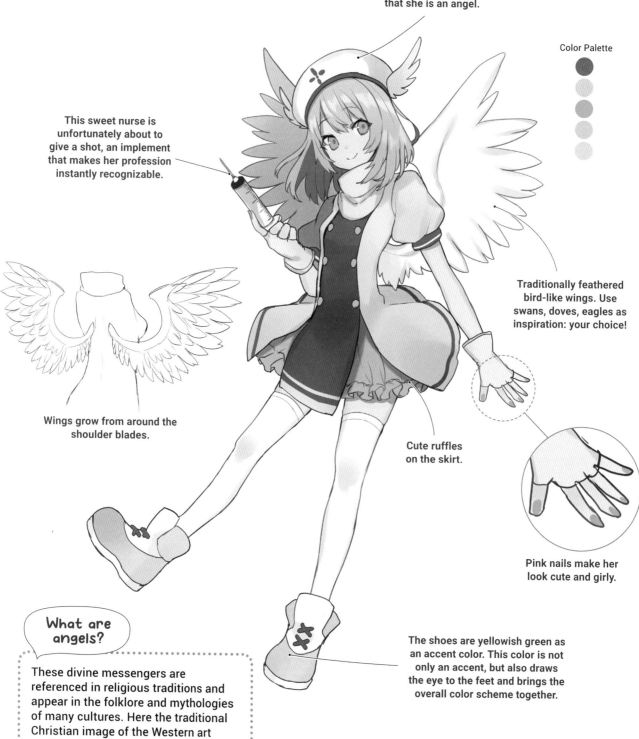

Traditionally feathered bird-like wings. Use swans, doves, eagles as inspiration: your choice!

Wings grow from around the shoulder blades.

Cute ruffles on the skirt.

Pink nails make her look cute and girly.

What are angels?

These divine messengers are referenced in religious traditions and appear in the folklore and mythologies of many cultures. Here the traditional Christian image of the Western art tradition is referenced, the winged cherubs bringing blessings and protection.

The shoes are yellowish green as an accent color. This color is not only an accent, but also draws the eye to the feet and brings the overall color scheme together.

The Devil

The traditional temptations of the Evil One are obscured by a large, loose-fitting hoodie, a soft pink instead of a devilish red, but her horned hood and nasty numbers immediately identify her.

The horns, which are often made in the motif of goats and sheep, are arranged in the shape of those motifs.

The number 666 is an obvious yet irresistible inclusion.

Bat-like wings also seemed appropriate here.

A hard-to-read expression. Is she all that diabolical?

Pointed ears are a must for a devilish character.

The pink hoodie is loose-fitting, obscuring the outline of her body and unifying the character's upper and lower halves.

Color Palette

The sneakers complement the hoodie, extending the pink palette all the way to her feet.

What are devils?

Like angels, devils feature in a number of religious and literary traditions, figures of evil, temptation and menace. They have no fixed form or appearance, often summoning goat-like or other bestial, dragonesque forms.

The shape of the tail is much different from a dragon's; the heart shape suggests her succubus side.

HELPFUL TIP

Devils and dragons share many common elements, such as horns and bat-like wings, which can be difficult to distinguish. In such cases, the devil's tail can be given a unique shape, or reptilian scales can be added to the dragon to differentiate them.

Character Design Notes

Here are some of the actual character designs and some of the character design drawings.

■ Himehina

A virtual unit consisting of Hime Tanaka and Hina Suzuki, they're mainly active in video distribution on YouTube, and sang and danced for the ending theme of the TV anime "VIRTUALSAN: LOOKING," broadcast in 2019.

Official website
https://www.himehina.com/

HimeHina Channel
https://www.youtube.com/c/himehina

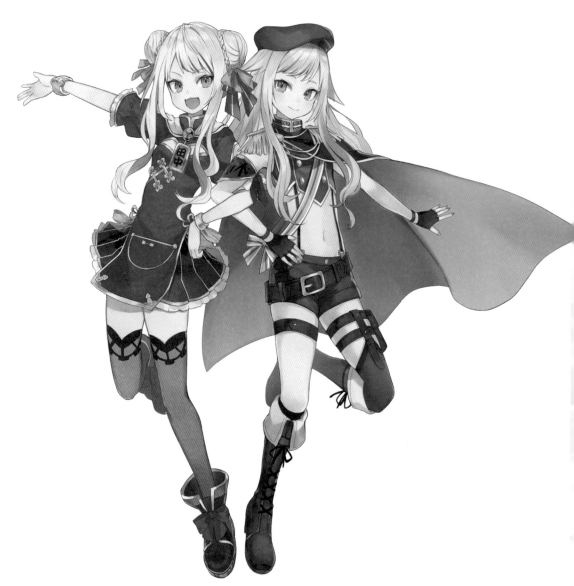

Hime Tanaka & Hina Suzuki's Sketches

Since they're a duo, we designed them with contrasting red and blue palettes to complement each other.

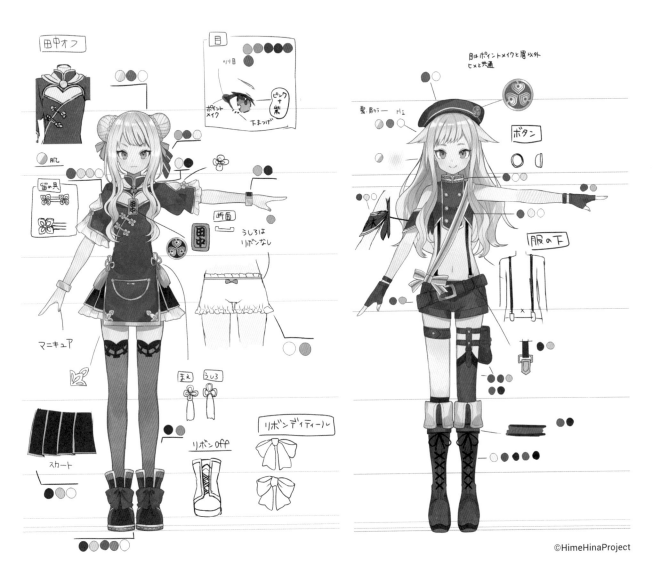

KMNZ (KEMONOZ)

A virtual hip-hop duo consisting of a dog-eared girl "LITA" and a cat-eared girl "LIZ," in 2018 they hosted the first talk variety show for VTubers on terrestrial TV, "VIRTUAL BUZZ TALK," and have been involved in a wide range of activities, including radio distribution and original music, mainly on YouTube.

Official website
https://www.kmnz.jp/

KMNZ LITA
https://www.youtube.com/KMNZLITA

KMNZ LIZ
https://www.youtube.com/KMNZLIZ

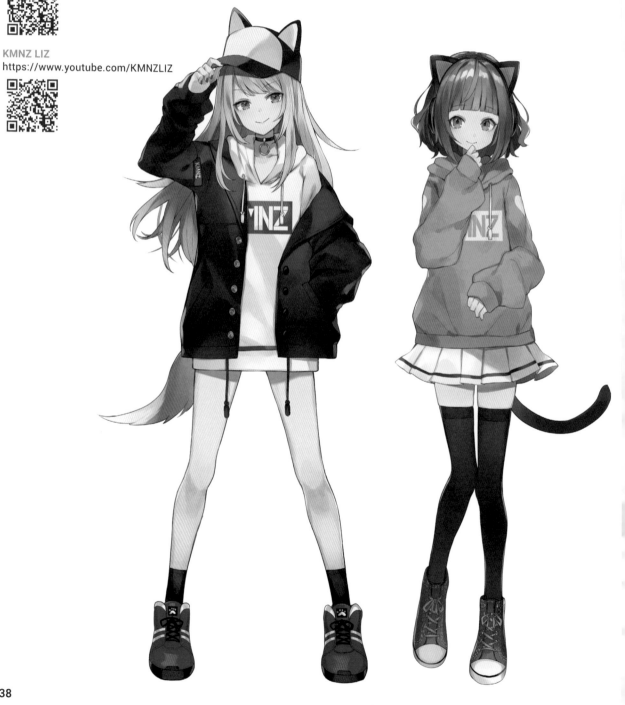

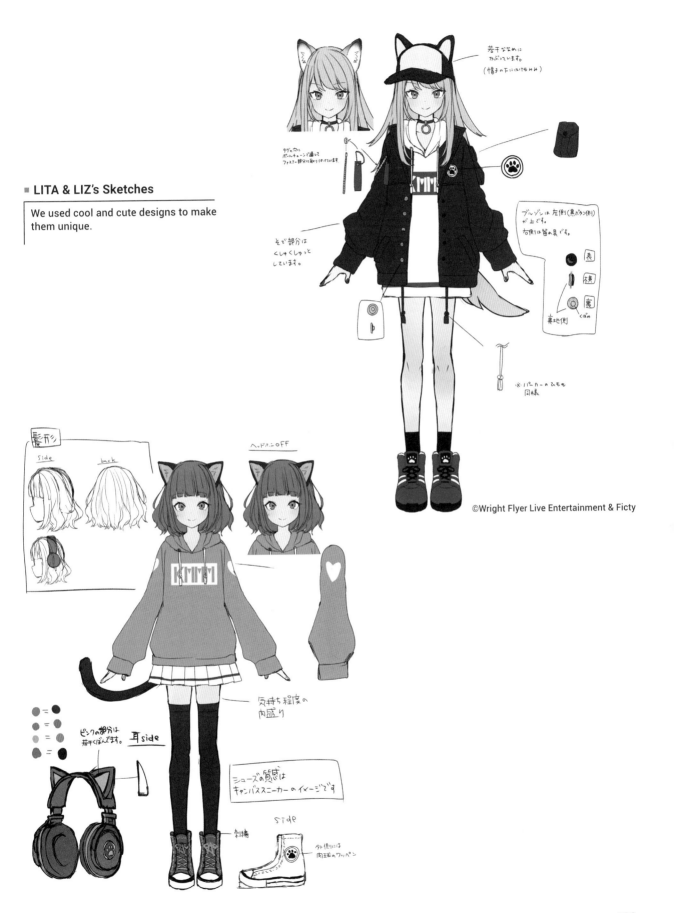

■ LITA & LIZ's Sketches

We used cool and cute designs to make them unique.

©Wright Flyer Live Entertainment & Ficty

Author's Profile

Shugao

An expert in all things furry and kemonomimi, she designed characters for "Virtual YouTubers Hime Tanaka & Hina Suzuki" and "Virtual Girls Unit KMNZ Rita & Liz," created card illustrations for "Z/X-Zillions of Enemy X" (Broccoli Co., Ltd.), illustrations for "Hatsune Miku 10th Anniversary Collaboration Store in Atre Akihabara" as well as illustrations for novels and social games.

References

Animals, David Burnie

Wildlife of the World, Smithsonian Institution

Encyclopedia of Wild Cats, Tadaaki Imaizumi

Encyclopedia of Wild Dogs, Tadaaki Imaizumi

The Beauty of the Cat: An Illustrated History, Tamsin Pickeral

The New Encyclopedia of the Dog, Bruce Fogle

New Pictorial Book of Domestic Rabbit Breeds, Osamu Machida

Rabbits, Hamsters and Squirrels, Doubutsu

Become a Goat Herder, Yagizuki Editorial Department

The Hedgehog, Mizue Ono

How to Keep Cute Ferrets, Mini Pet Club

Illustration Introduction to Livestock Production, Hironori Yagi

Mammals in Comparative Perspective, Teruyuki Komiya

Birds, BirdLife International

How to Draw Kemomimis, YANAMI, Hisona, Saya, Ju Ayakura (GENKOSHA)

Websites

Everyone's Cat Encyclopedia
 https://www.min-nekozukan.com/

Everyone's Dog Encyclopedia
 https://www.min-inuzukan.com/

Following stock photos from stock.adobe.com
Pages 23, 96 o_shi; **34, 43** Kirill Vorobyev; **35 top, 37, 67 bottom** Aleksand Volchanskiy; **35 bottom** nelik; **36** suwatwongkham; **38, 45 top** serkucher; **39** Sarah Fields; **40, 61 right;** 66 jagodka; **42** adisa; **44** dionoanomalia; **45 bottom** Callalloo Twisty; **46, 48, 57, 60, 61 left, 95 bottom, 106, 107 top, 109, 119, 121 bottom, 124, 125 top** Eric Isselée; **47 top** Robin; **47 bottom** mareandmare; **49** Alexander Potapov; **50 top** vladislav333222; **50 bottom** kjekol; **56** dvr; **58, 64** TrapezaStudio; **59** Kang Sunghee; **62** 5second; **63** Lisa Svara; **65 top** JackF; **65 bottom** Rita Kochmarjova; **67 top** Pavel Hlystov; **68** feathercollector; **75** FotoRequest; **76** Frank Fichtmüller; **78** Vladimir Wrangel; **79 top, 85** jimcumming88; **79 bottom** Vera Kuttelvaserova; **86** tikhomirovsergey; **94** Julia; **95 top** pandpstock001; **97** rachaphak; **98** Oksana Schmidt; **102** Rafael Ben-Ari; **103** Molly; **104** Marcin; **105 left** fotoparus; **105 right** anankkml; **107 bottom** alberto; **108** irinamaksimova; **110 left** brandtbolding; **110 right** saprygins; **111** Linda More; **113** Roger; **114** kogera; **115 top** gallinago_media; **115 bottom** Friedemeier; **116** Oleg Kozlov; **117** yevgeniy11; **118** Pantherius; **120** Stephan Morris; **121 top** vandycandy; **122** Alexey Seafarer; **123** wusuowei; **125 bottom** salajean; **126** asfloro; **127** mgkuijpers

Published by Tuttle Publishing, an imprint of Periplus Editions (HK) Ltd

www.tuttlepublishing.com

ISBN 978-4-8053-1769-3

KEMONOMIMI CHARACTER DESIGN BOOK
© 2015 shugao
© 2015 GENKOSHA CO., Ltd.
English translation rights arranged with GENKOSHA CO., Ltd.
through Japan UNI Agency, Inc., Tokyo

English Translation © 2023 Periplus Editions (HK) Ltd

Staff (Original Japanese edition)
Author Shugao
Planning, composition, editing Tomohiro Namba
(REMIC Co., Ltd.)
Editorial assistance Tomohiro Arai (REMIC Co., Ltd.),
Ayumi Yamaguchi
Design Masayasu Hirota
Publisher Hiroshi Kitahara
Editor Toshimitsu Katsuyama

Distributed by

**North America,
Latin America & Europe**
Tuttle Publishing
364 Innovation Drive
North Clarendon
VT 05759-9436 U.S.A.
Tel: 1 (802) 773-8930
Fax: 1 (802) 773-6993
info@tuttlepublishing.com
www.tuttlepublishing.com

Japan
Tuttle Publishing
Yaekari Building 3rd Floor
5-4-12 Osaki
Shinagawa-ku
Tokyo 141-0032
Tel: (81) 3 5437-0171
Fax: (81) 3 5437-0755
sales@tuttle.co.jp
www.tuttle.co.jp

Asia Pacific
Berkeley Books Pte. Ltd.
3 Kallang Sector #04-01
Singapore 349278
Tel: (65) 6741-2178
Fax: (65) 6741-2179
inquiries@periplus.com.sg
www.tuttlepublishing.com

TUTTLE PUBLISHING® is a registered trademark of Tuttle Publishing, a division of Periplus Editions (HK) Ltd.

26 25 24 23 10 9 8 7 6 5 4 3 2 1
Printed in China 2309EP

"Books to Span the East and West"

Tuttle Publishing was founded in 1832 in the small New England town of Rutland, Vermont [USA]. Our core values remain as strong today as they were then—to publish best-in-class books which bring people together one page at a time. In 1948, we established a publishing outpost in Japan—and Tuttle is now a leader in publishing English-language books about the arts, languages and cultures of Asia. The world has become a much smaller place today and Asia's economic and cultural influence has grown. Yet the need for meaningful dialogue and information about this diverse region has never been greater. Over the past seven decades, Tuttle has published thousands of books on subjects ranging from martial arts and paper crafts to language learning and literature—and our talented authors, illustrators, designers and photographers have won many prestigious awards. We welcome you to explore the wealth of information available on Asia at **www.tuttlepublishing.com**.